Ramon H. Lopez – The Rustpainter – Second Book Edition

WELCOME! Please enjoy this Ramon H. Lopez Second Art Book Edition with collection of his paintings. You may display this book as coffee table book in your living room, as conversation piece. You may give this as gift. You may cut out and frame each page, sized at 8.5x11 inches and suitable for framing, and for wall decors. Some of his works are for sale. You can also commission him for art jobs. He can be contacted easily at facebook. He lives in San Jose, Nueva Ecija.

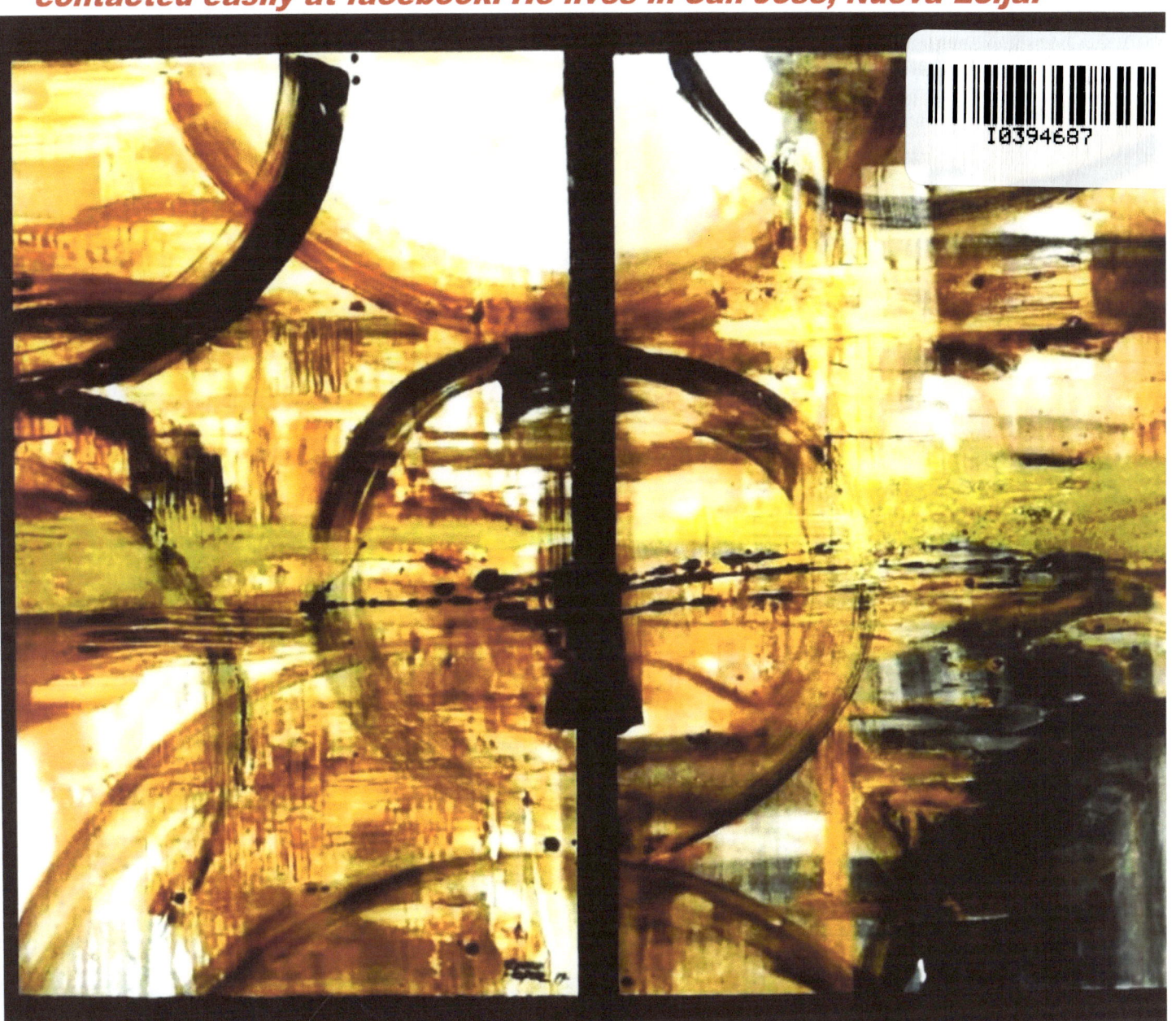

Self-Publisher - Tatay Jobo Elizes - Printed in USA under ISBN codes below.
ISBN-13: 978 - 1548267667 + ISBN-10: 154826766X
job_elizes@yahoo.com + Websites: http://tinyurl.com/mj76ccq -
www.jobelizes6.wix.com/mysite
"Buy A Book or Gift for Somebody - paperback or kindle edition online"

Ramon H. Lopez – The Rustpainter – Second Book Edition

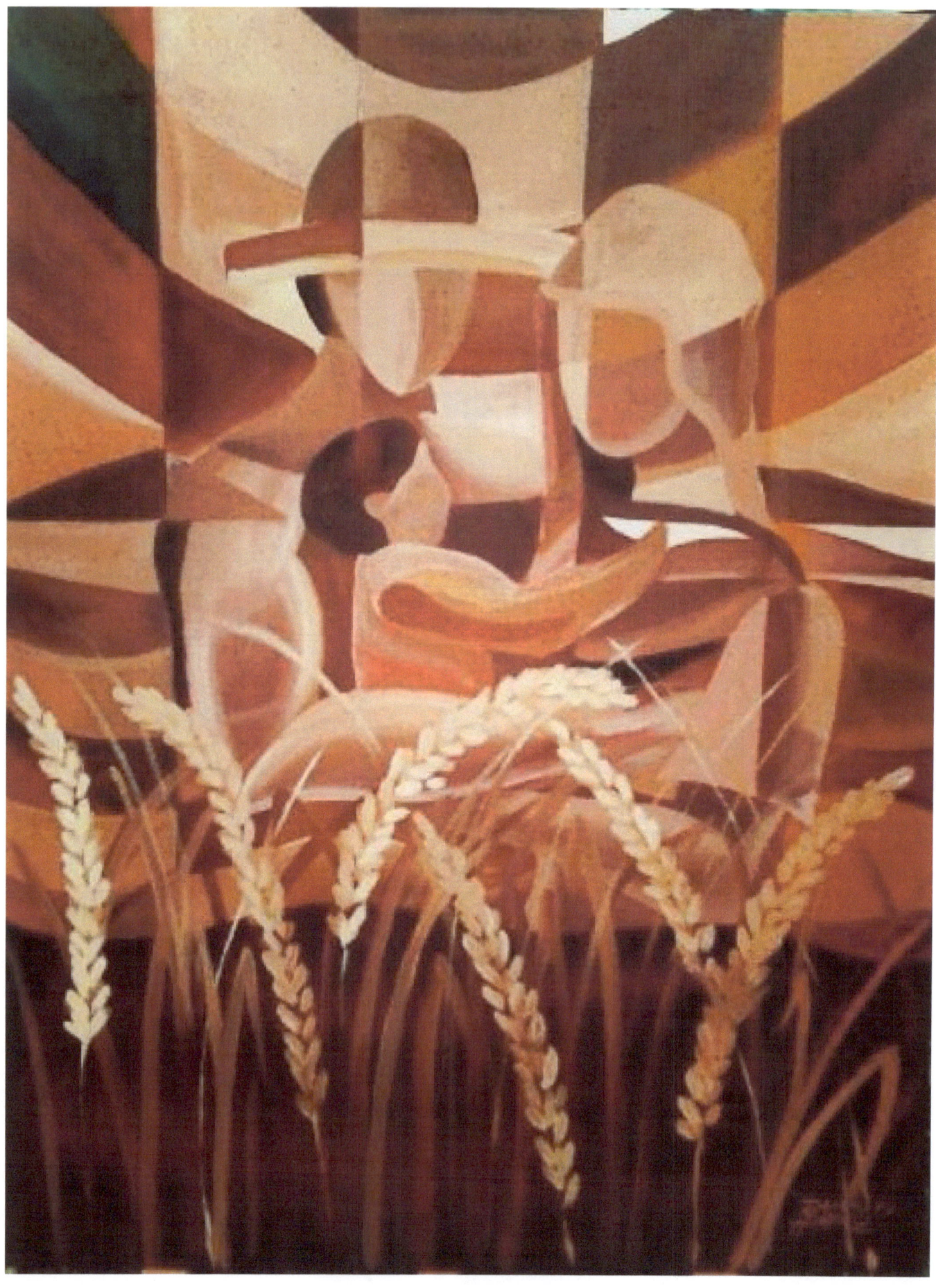

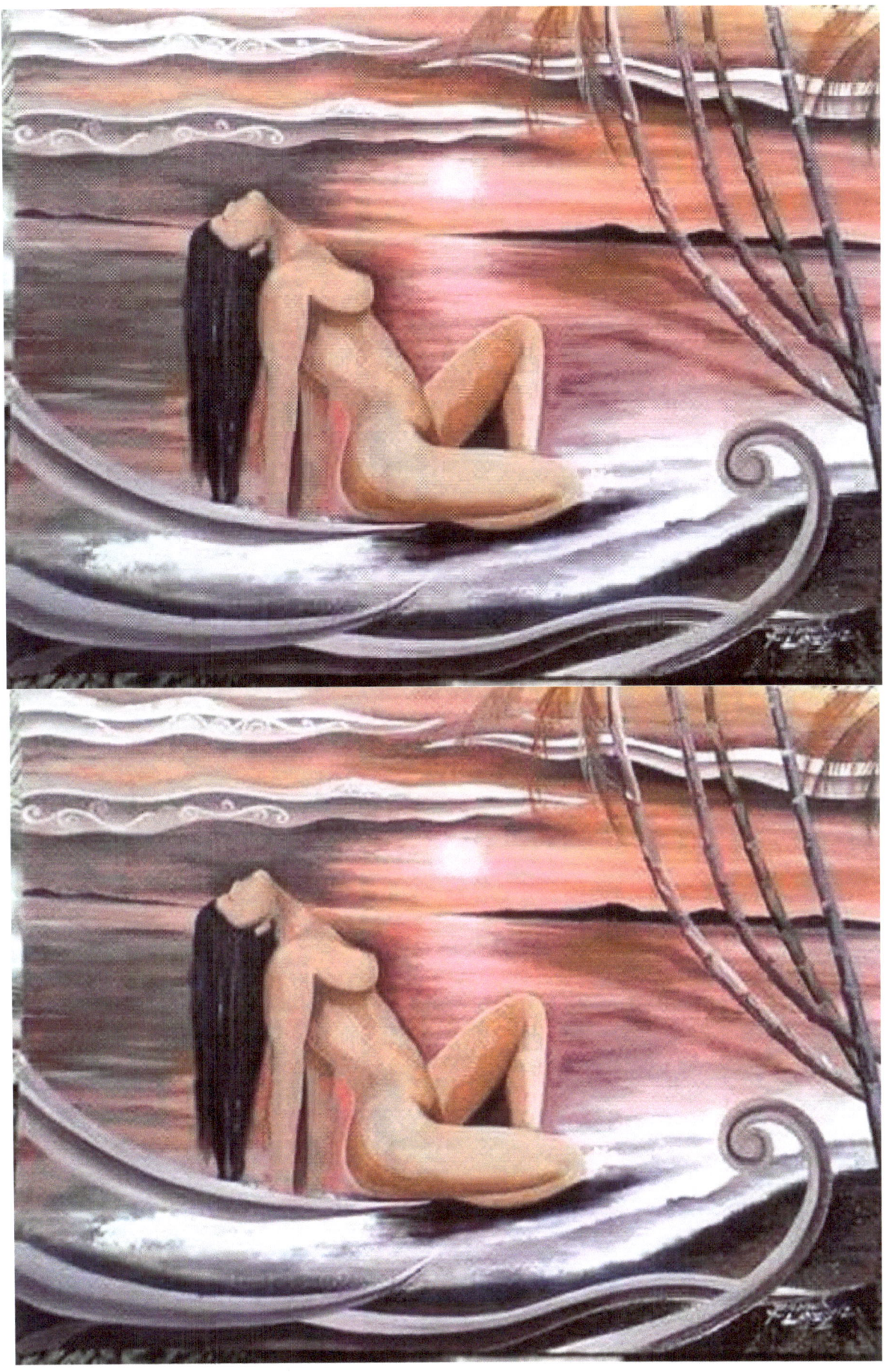

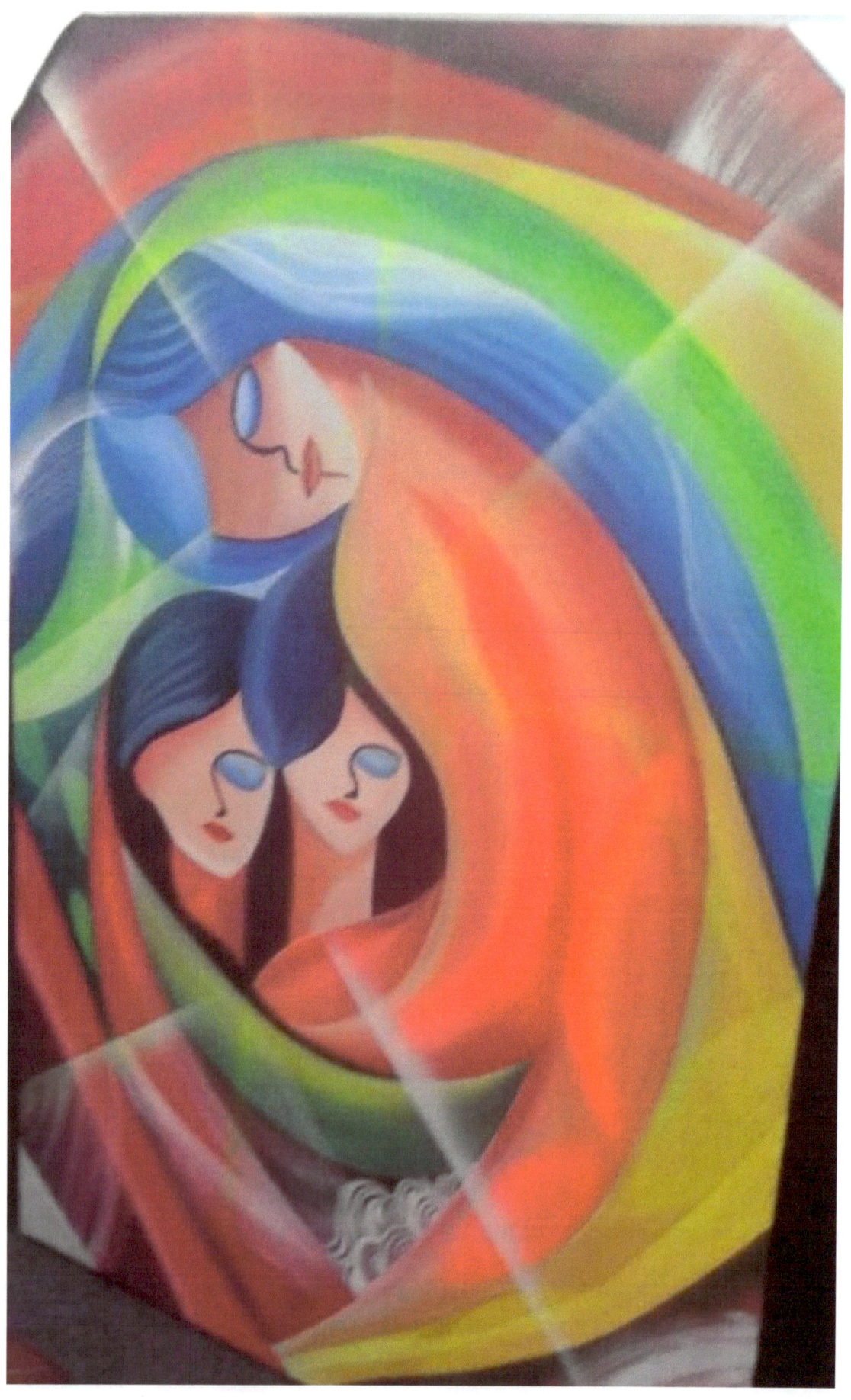

Ramon H. Lopez – The Rustpainter – Second Book Edition

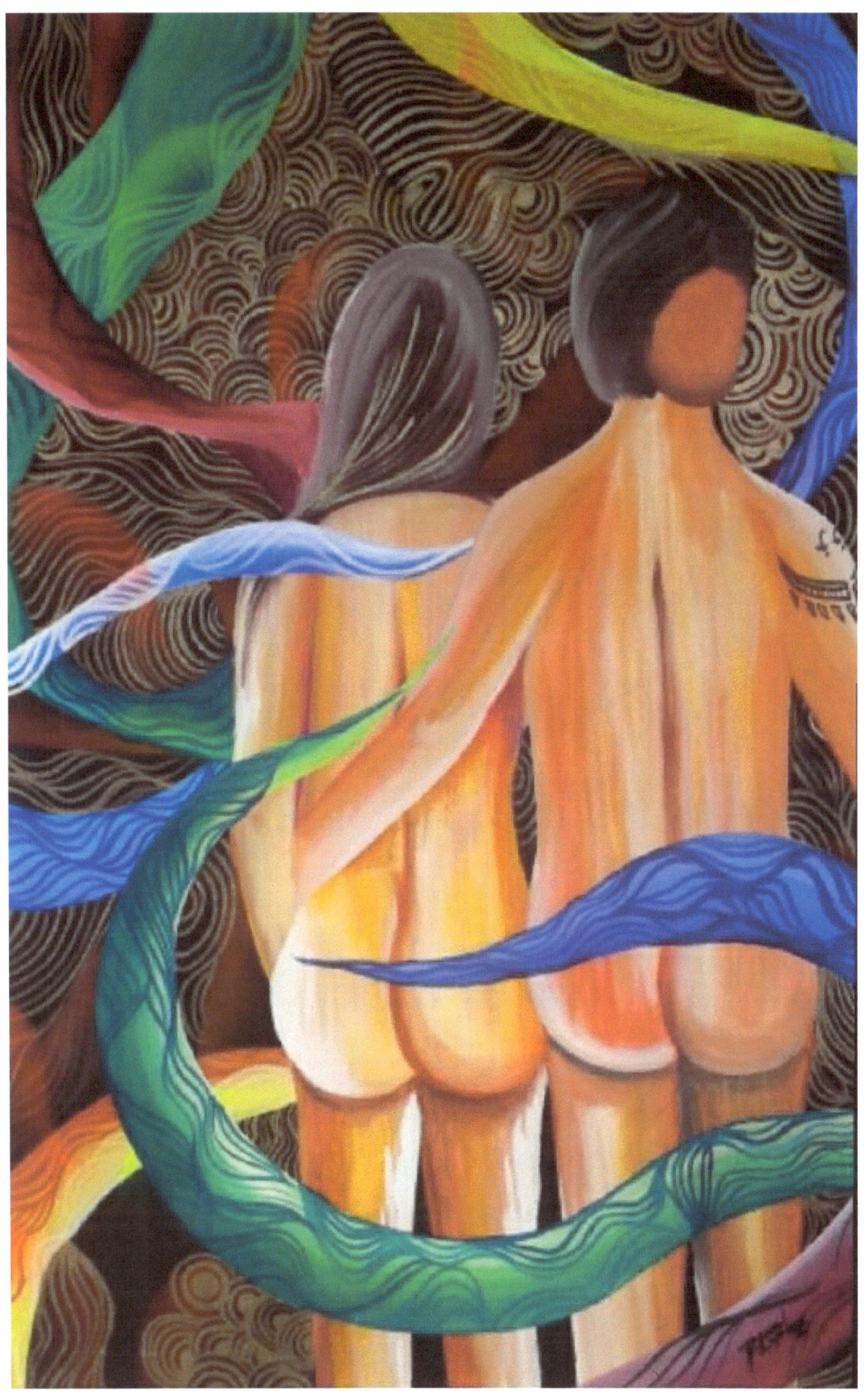

Ramon H. Lopez – The Rustpainter – Second Book Edition

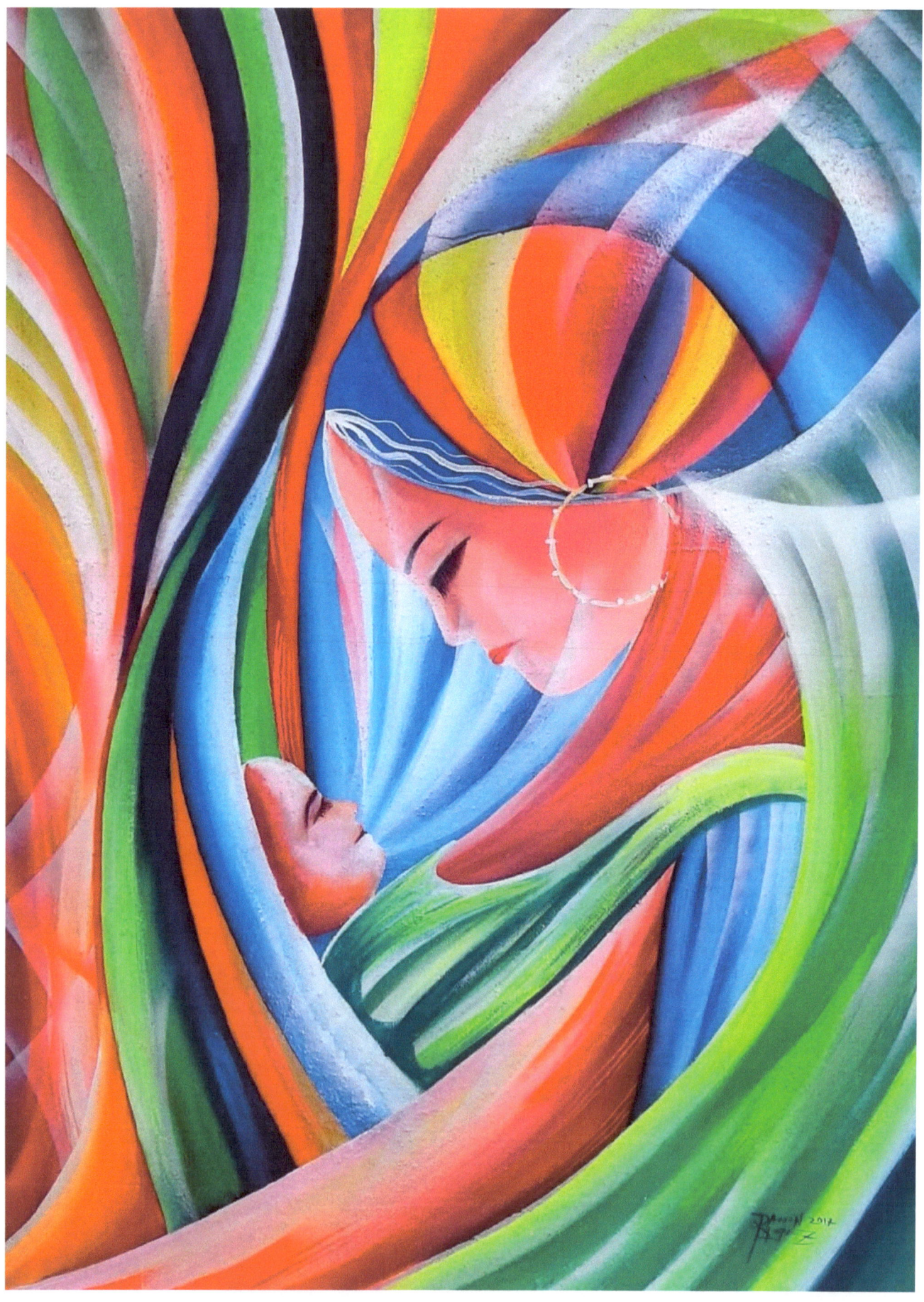

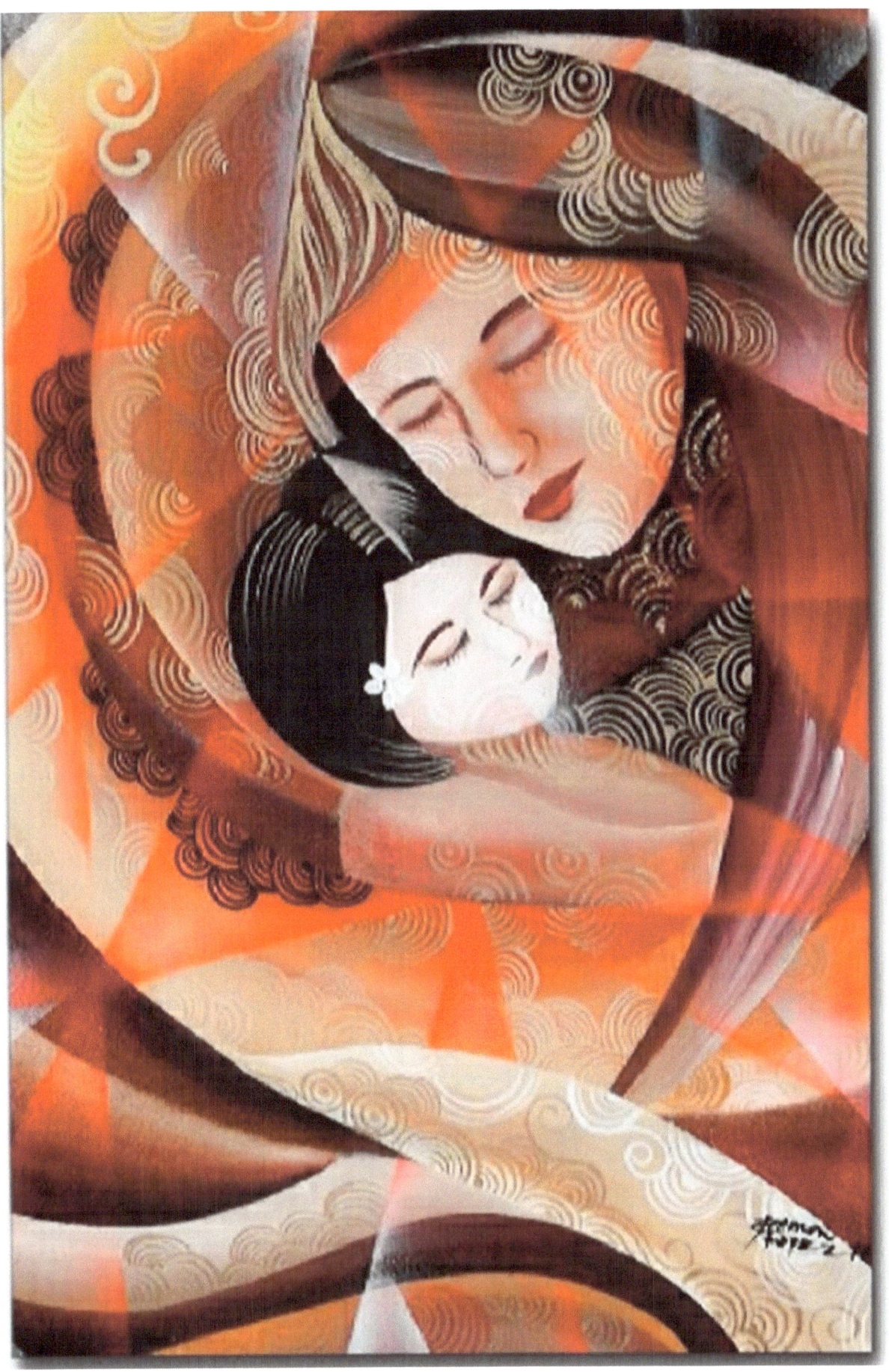

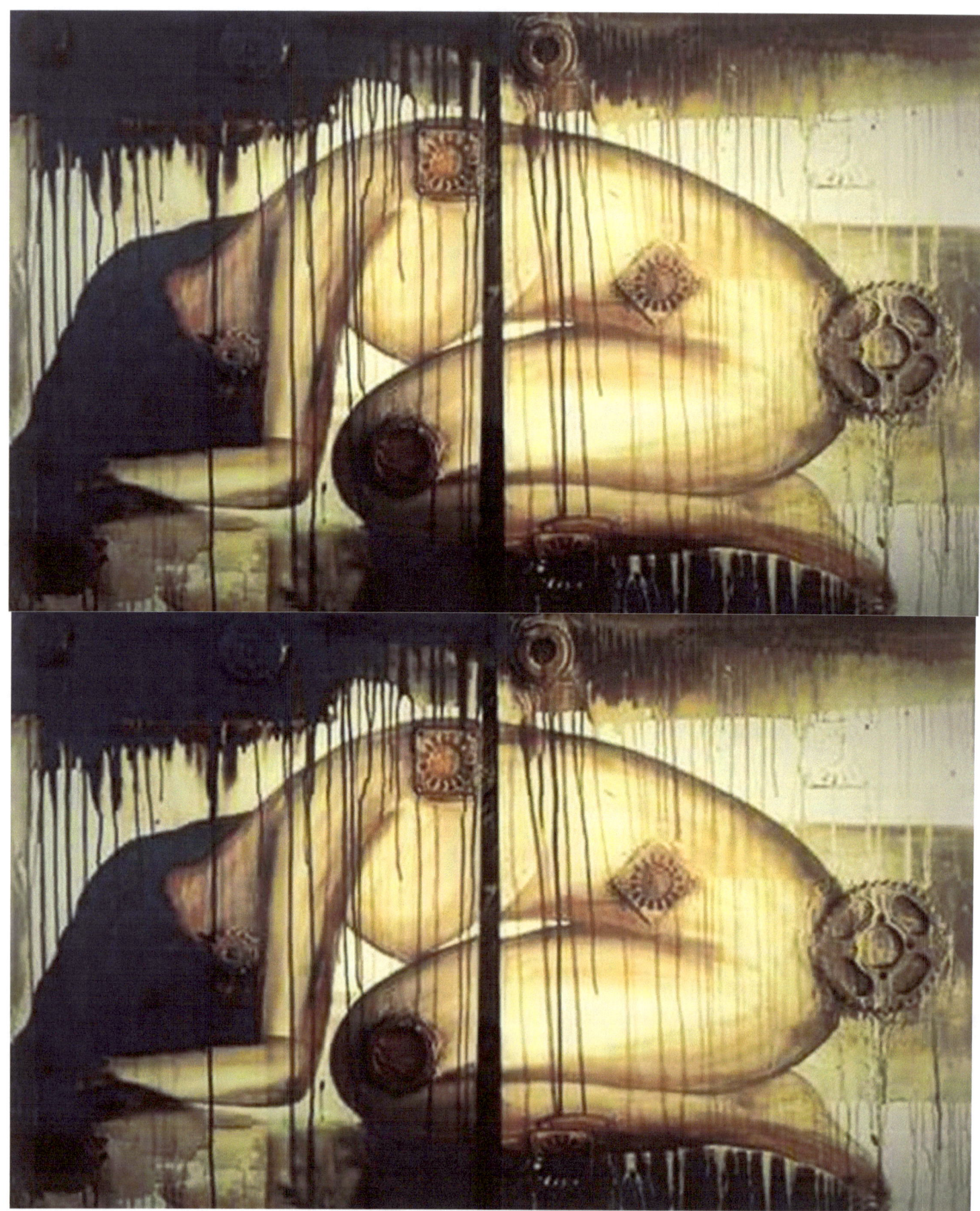

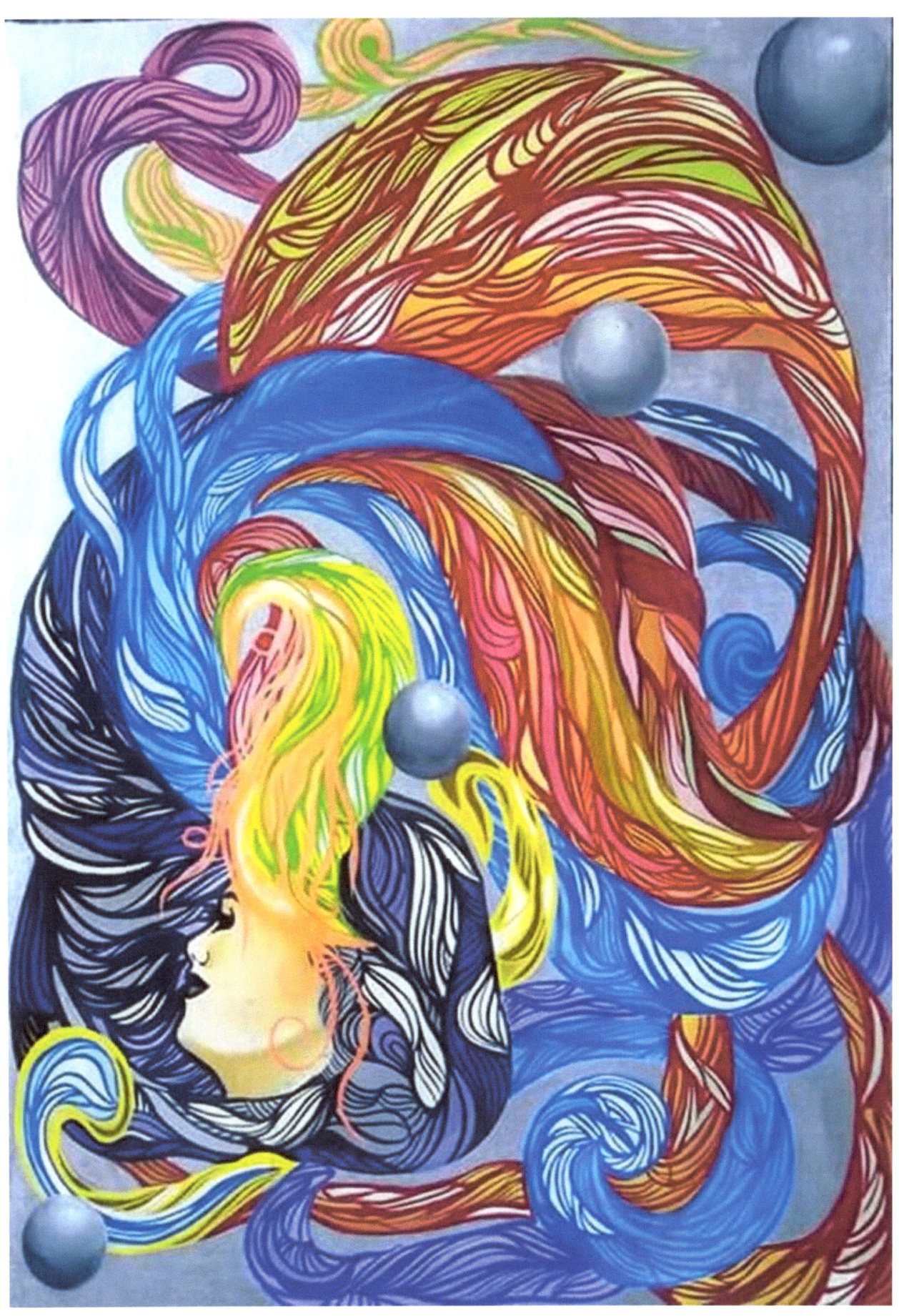

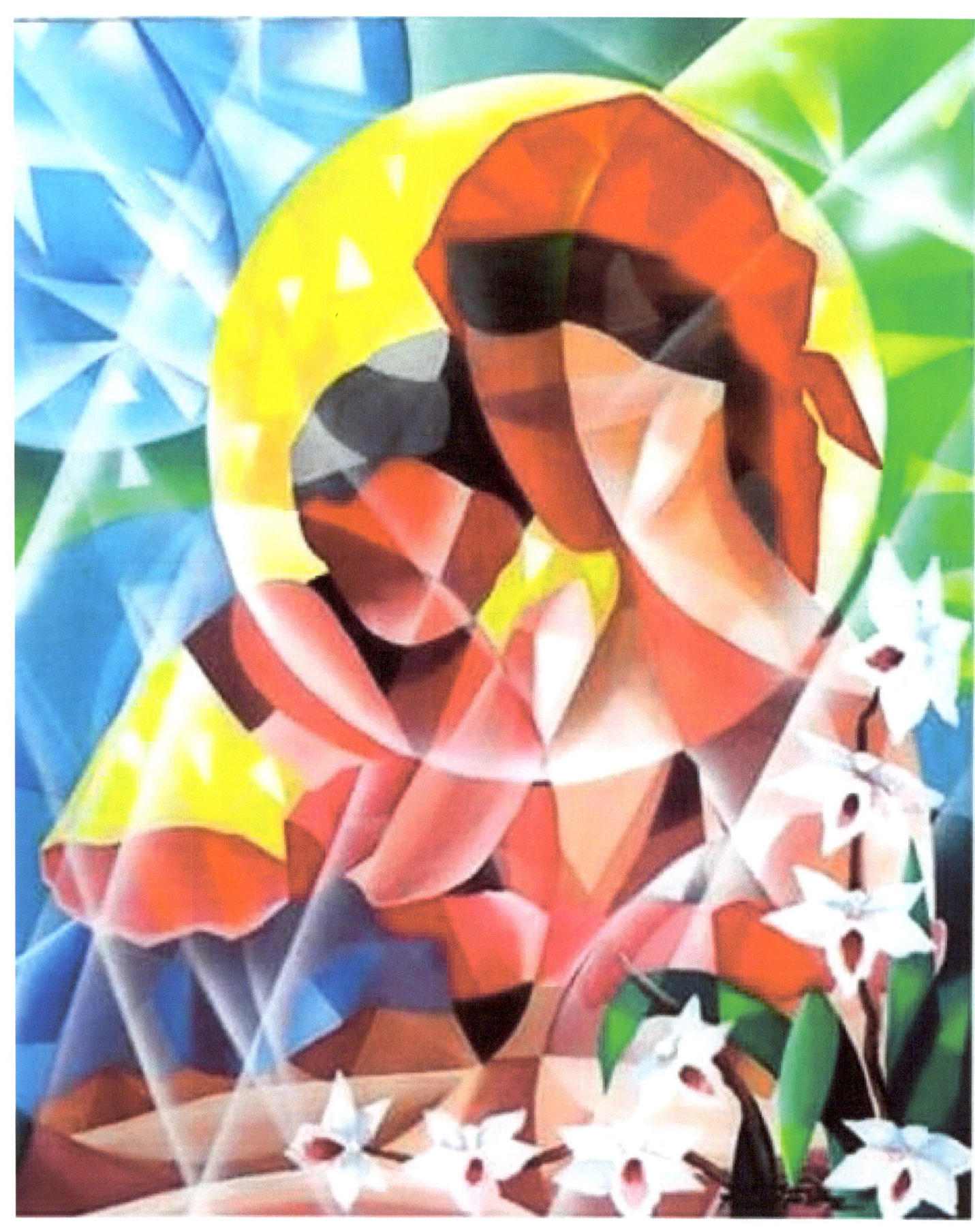

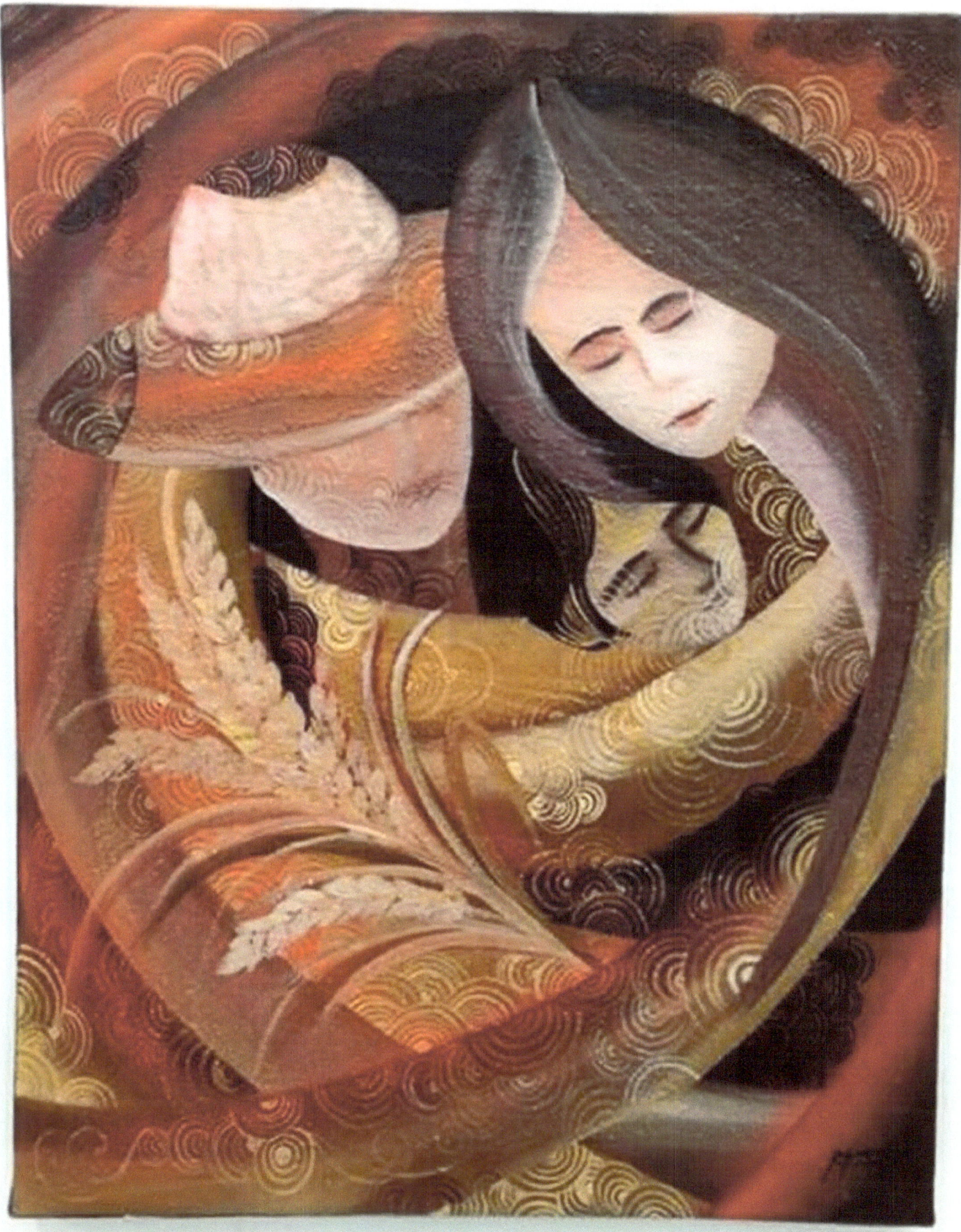

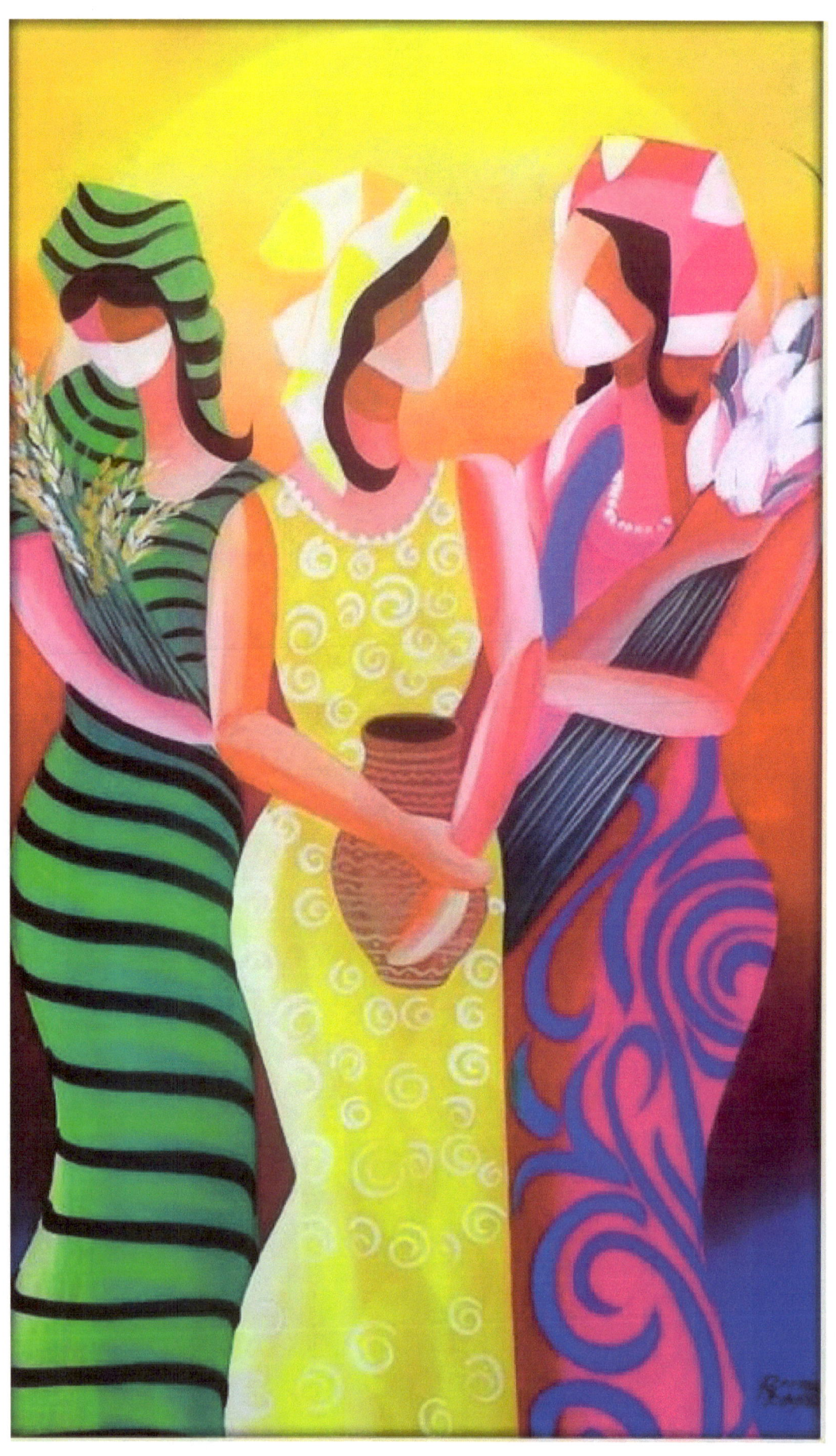

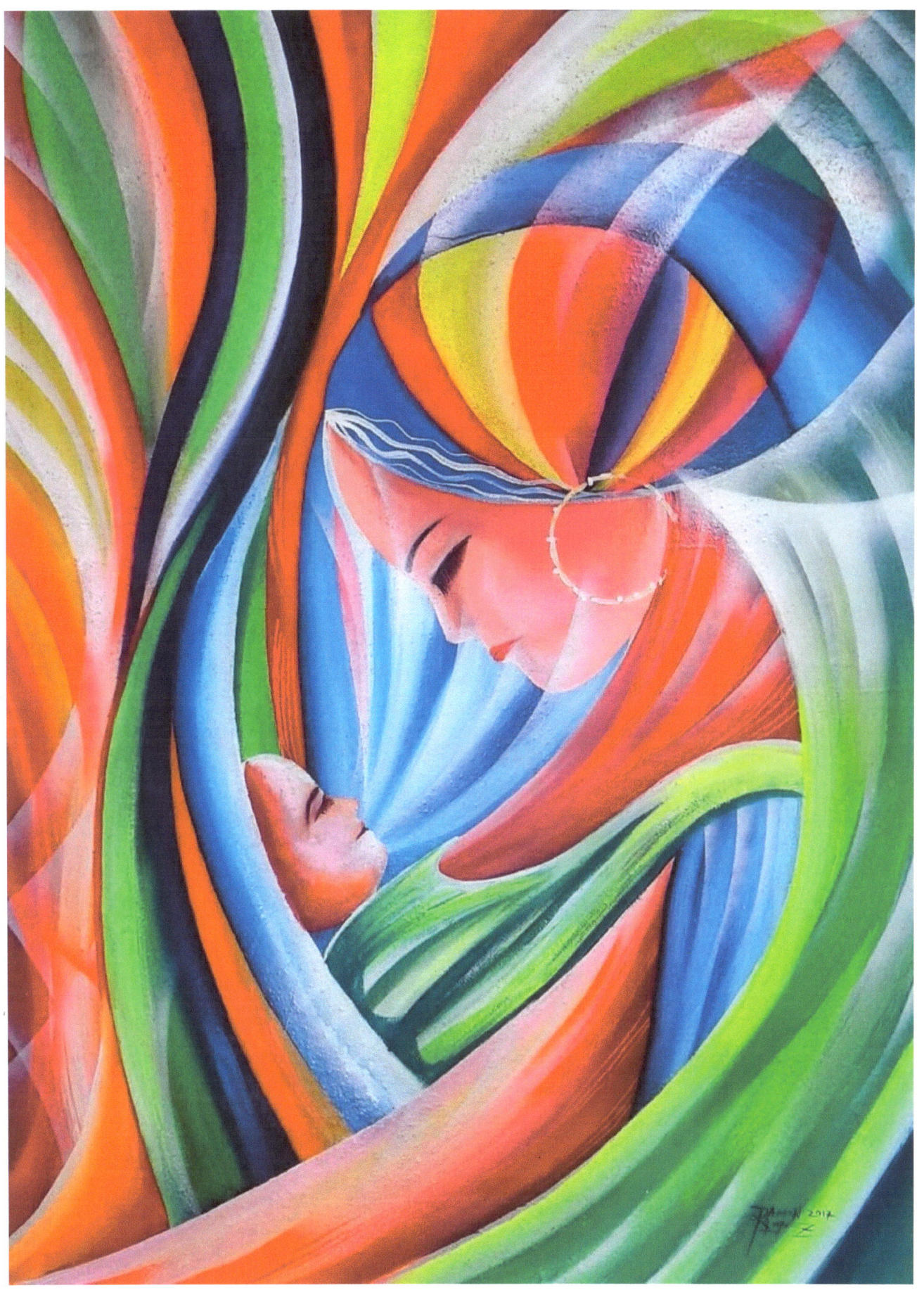

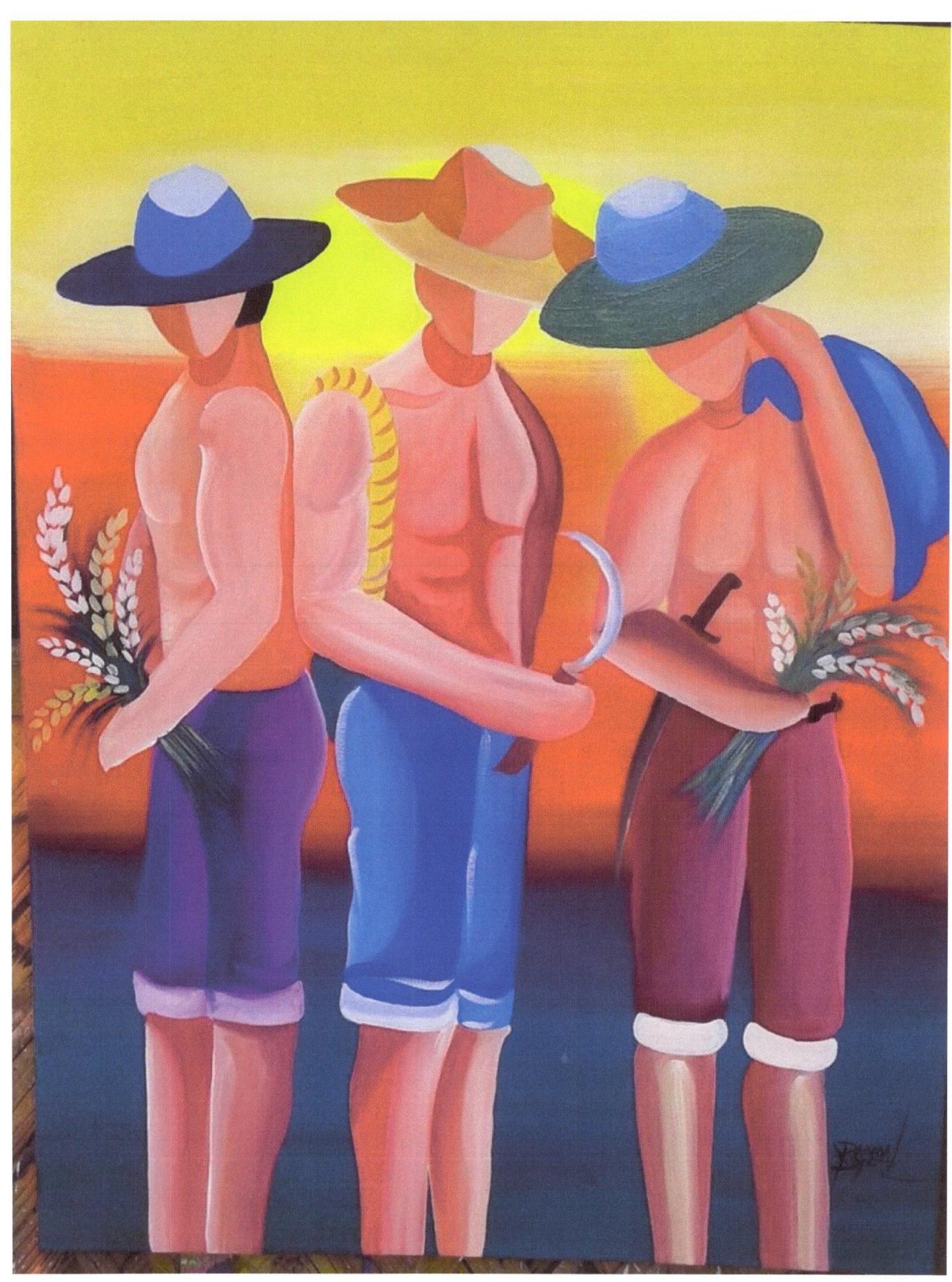

Ramon H. Lopez – The Rustpainter – Second Book Edition

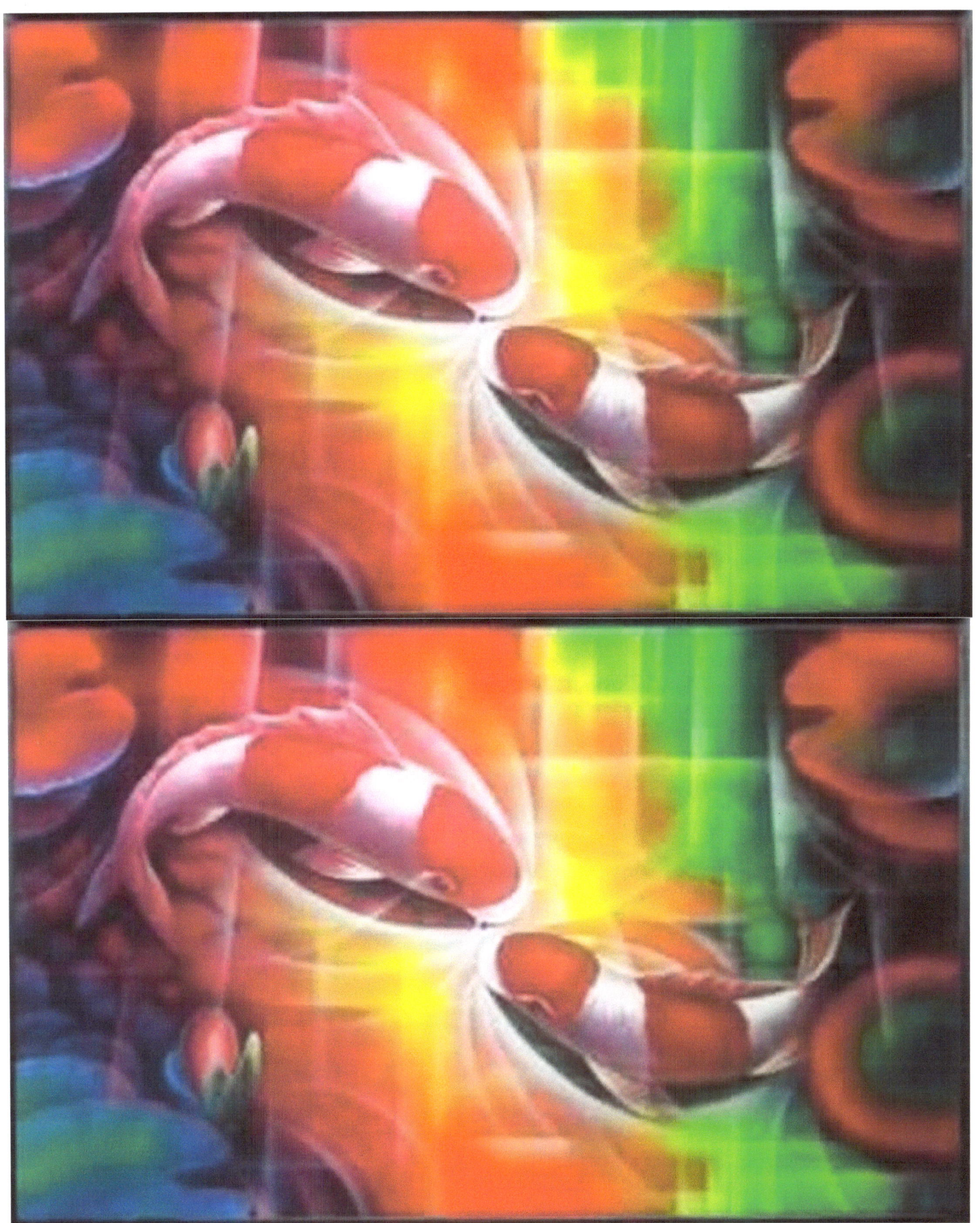

Ramon H. Lopez – The Rustpainter – Second Book Edition

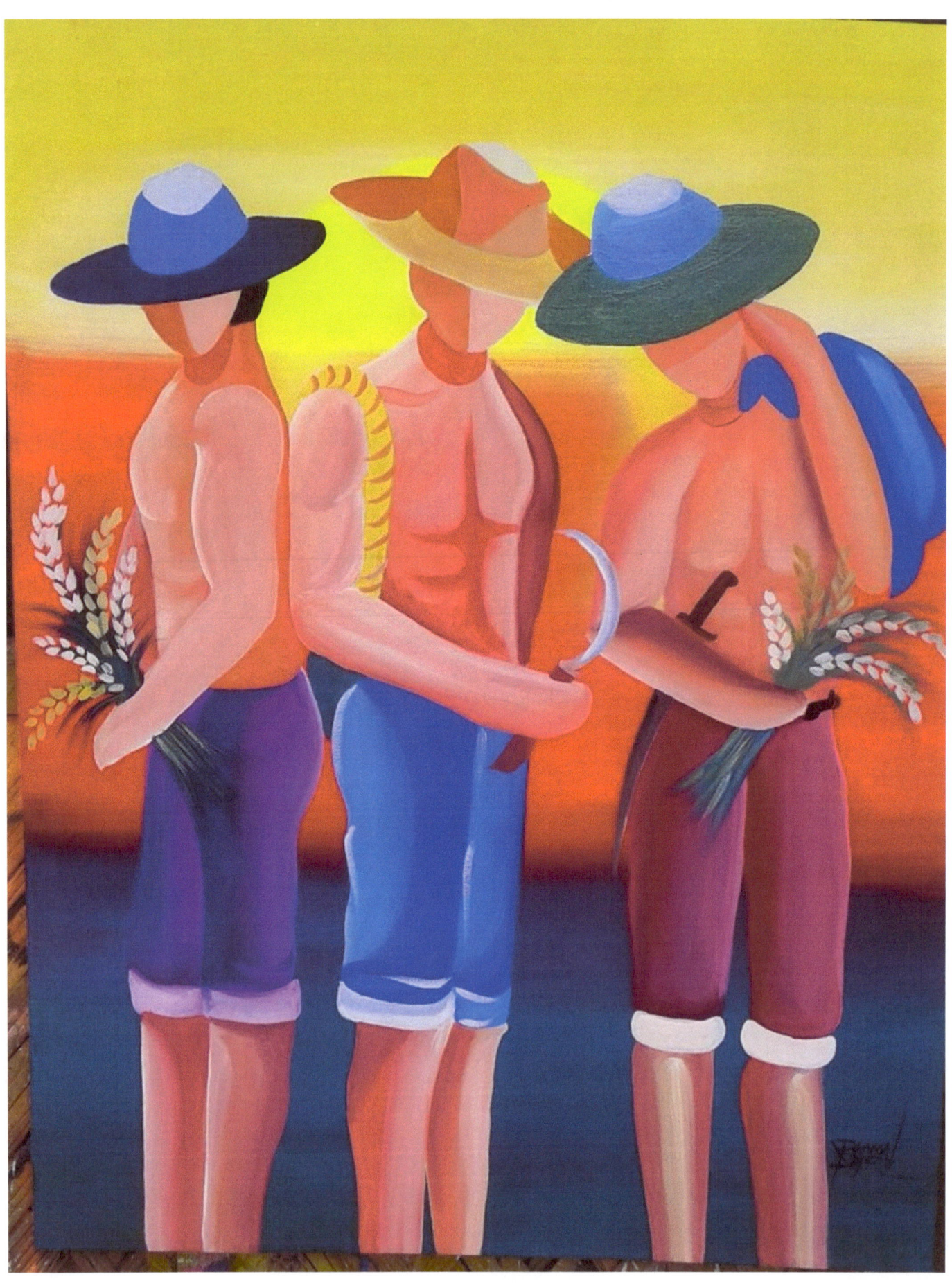

Ramon H. Lopez – The Rustpainter – Second Book Edition

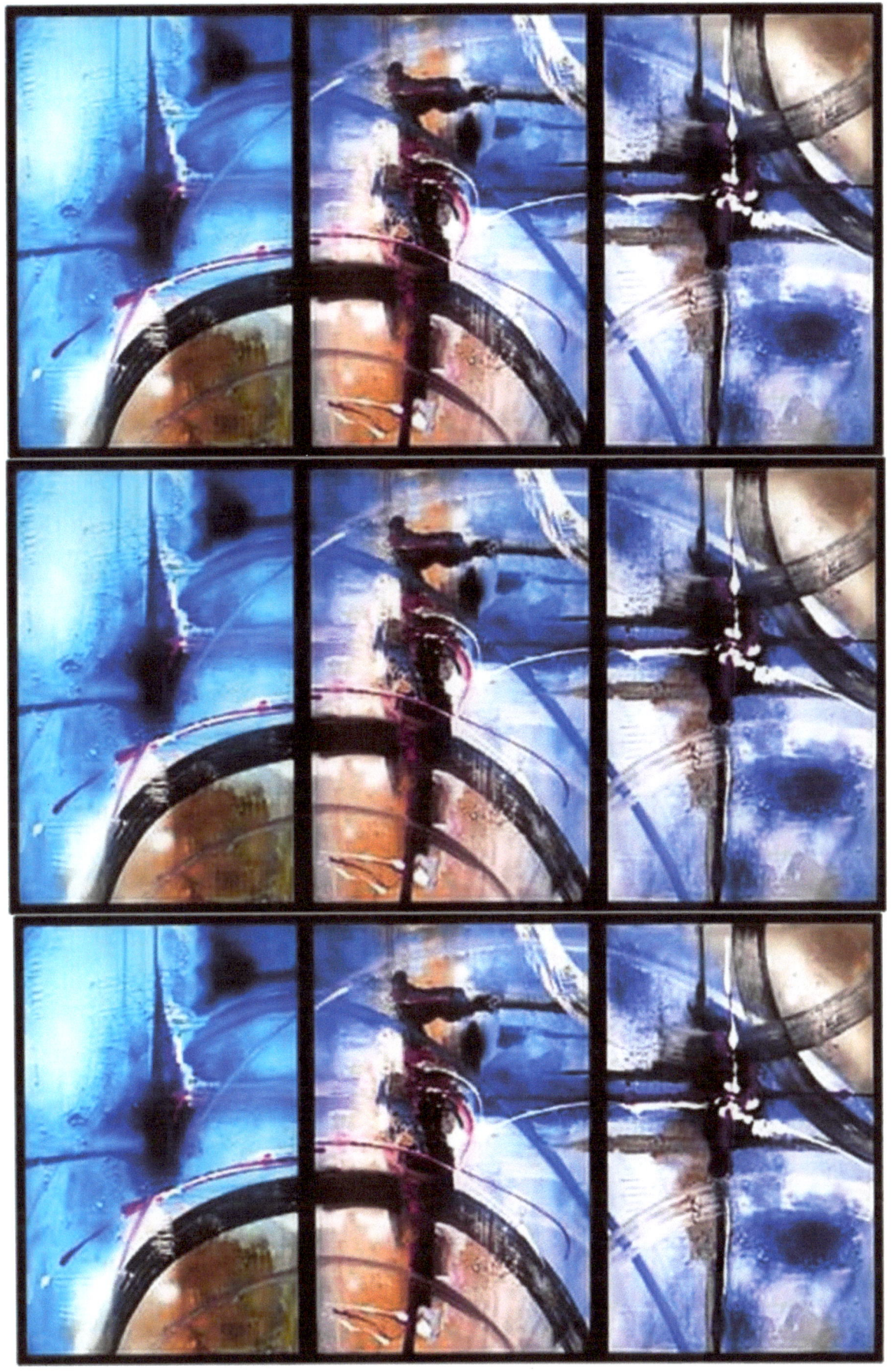

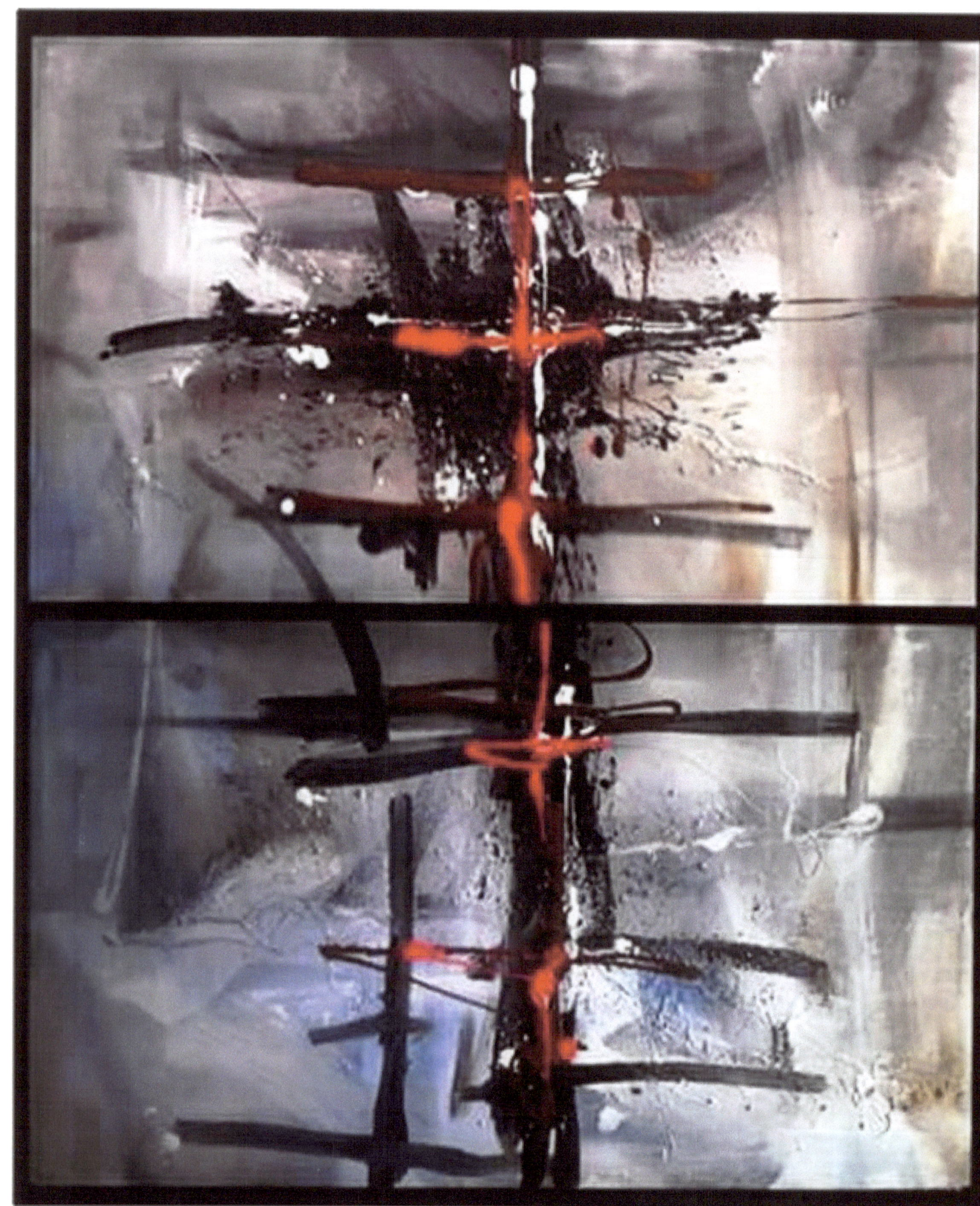

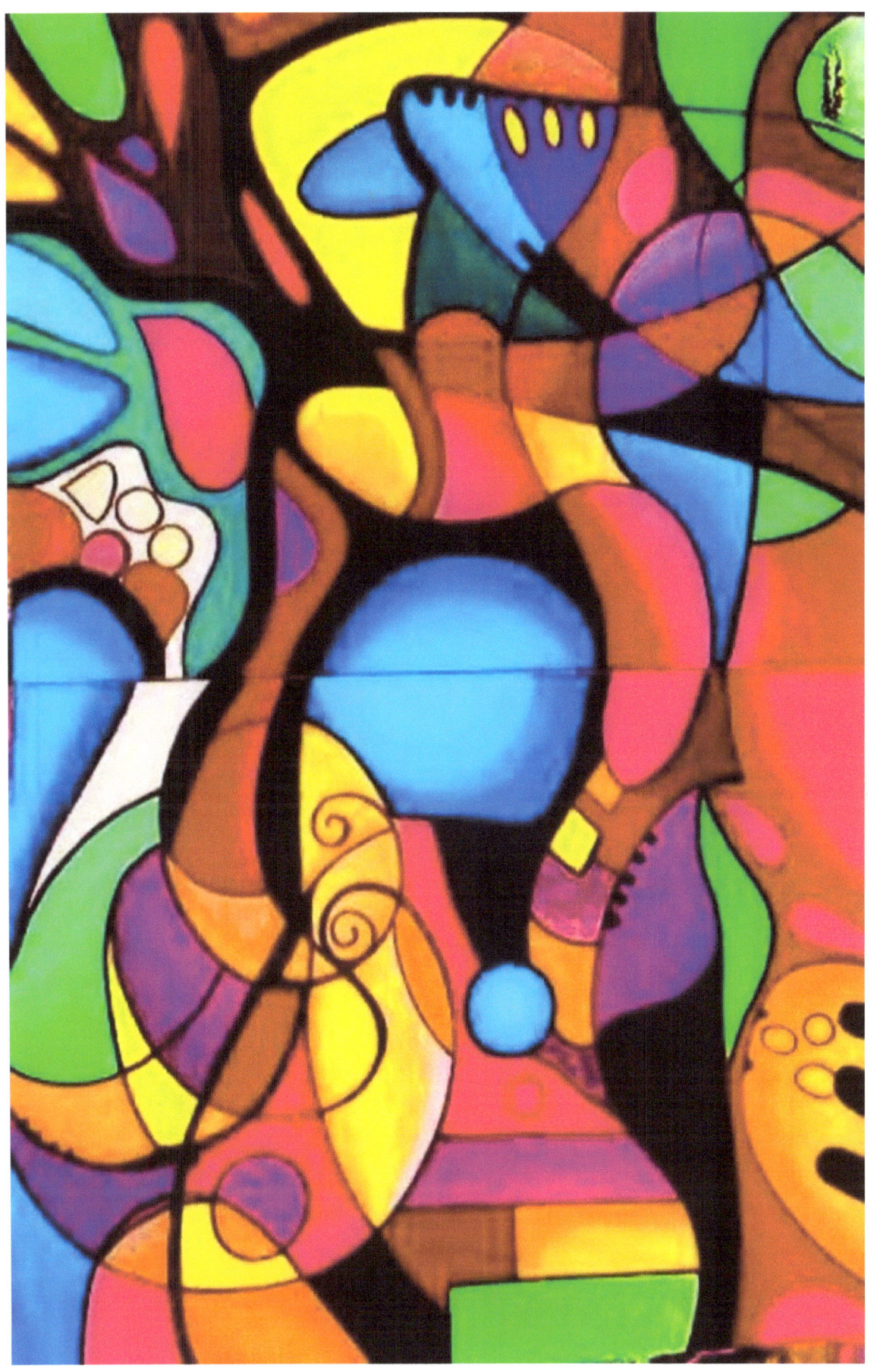

Ramon H. Lopez – The Rustpainter – Second Book Edition

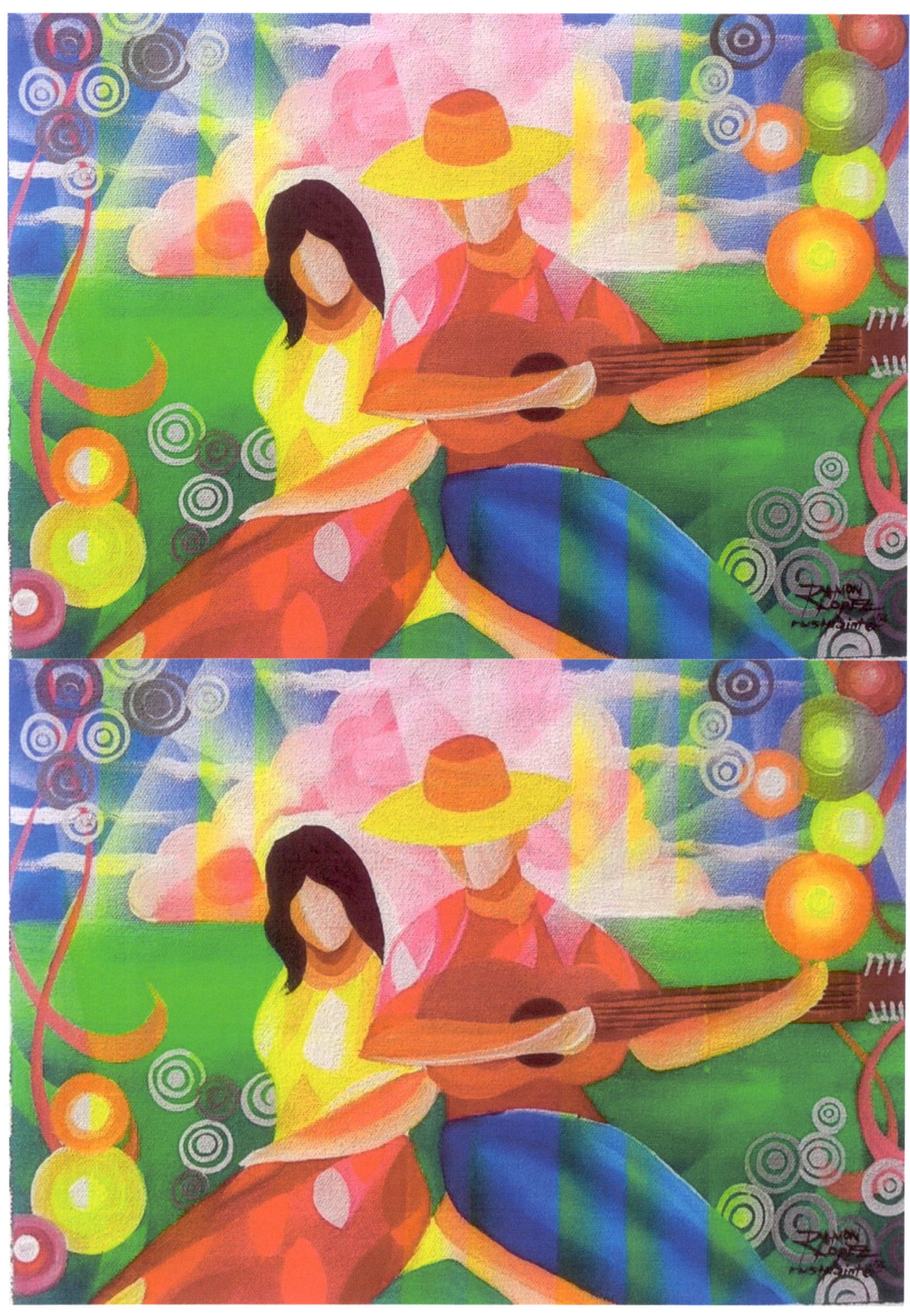

Ramon H. Lopez – The Rustpainter – Second Book Edition

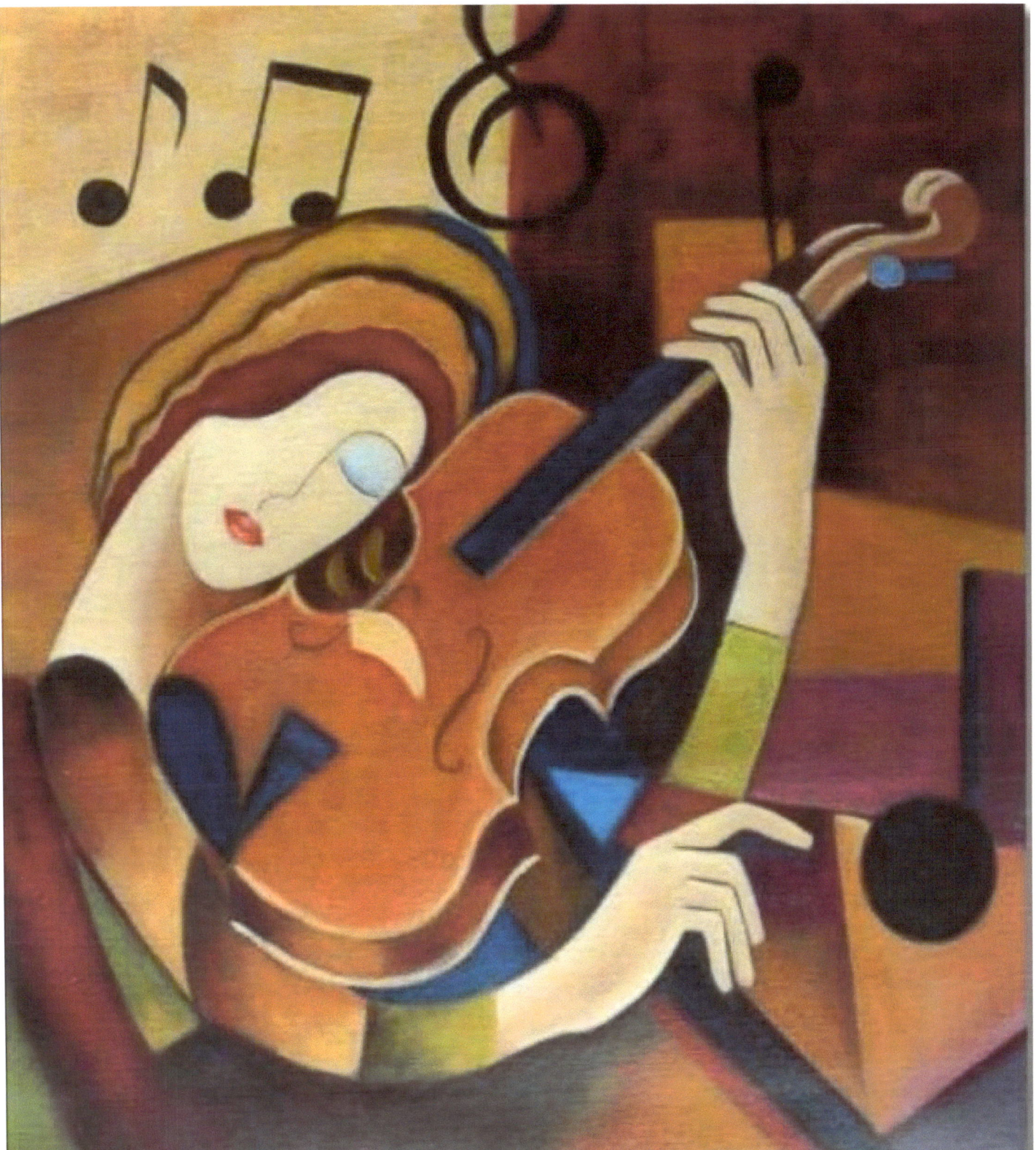

WELCOME! Please enjoy this Ramon H. Lopez Second Art Book Edition with collection of his paintings. You may display this book as coffee table book in your living room, as conversation piece. You may give this as gift. You may cut out and frame each page, sized at 8.5x11 inches and suitable for framing, and for wall decors. Some of his works are for sale. You can also commission him for art jobs. He can be contacted easily at facebook. He lives in San Jose, Nueva Ecija, Philippines.

Ramon H. Lopez – The Rustpainter – Second Book Edition

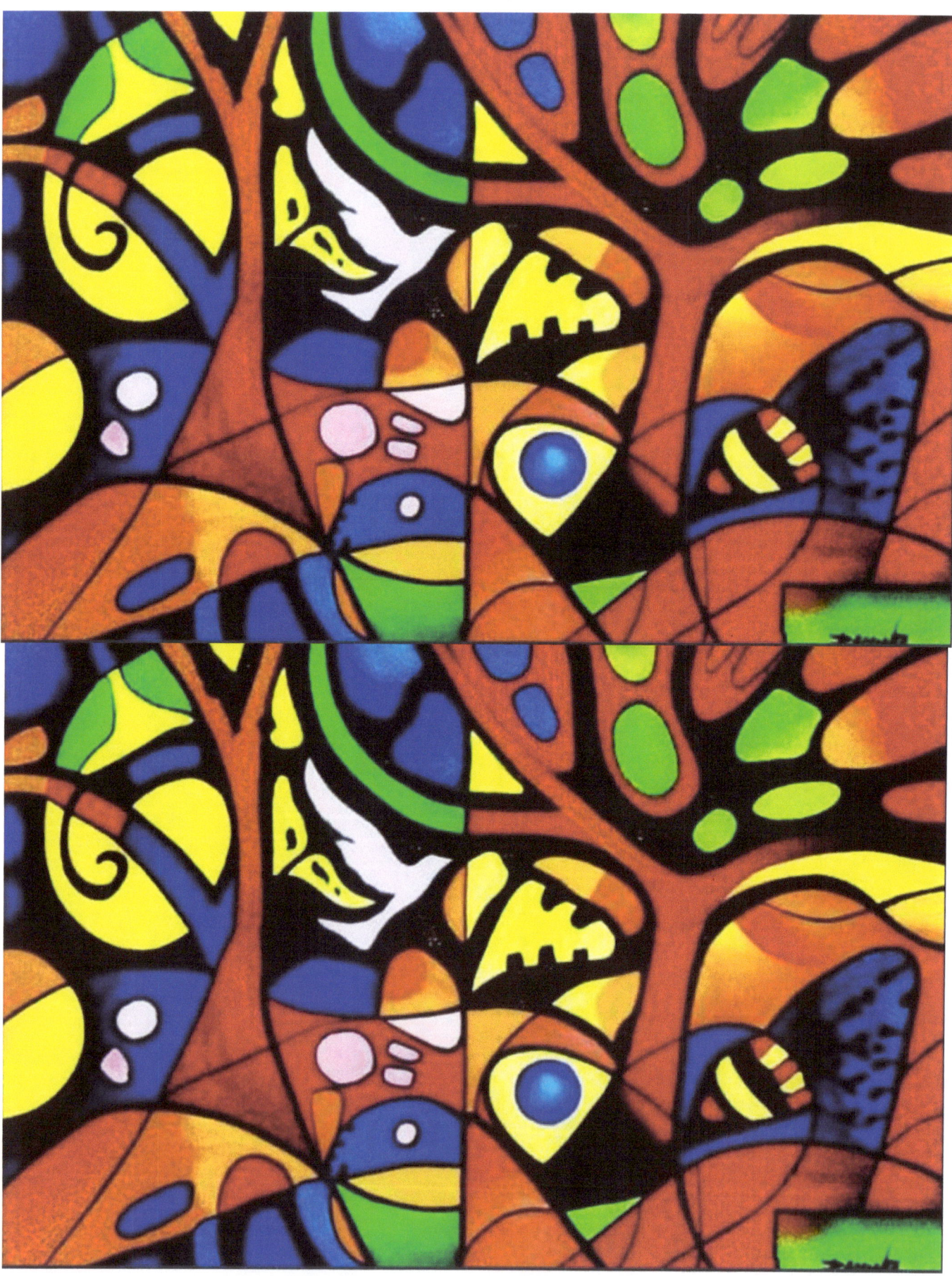

Ramon H. Lopez – The Rustpainter – Second Book Edition

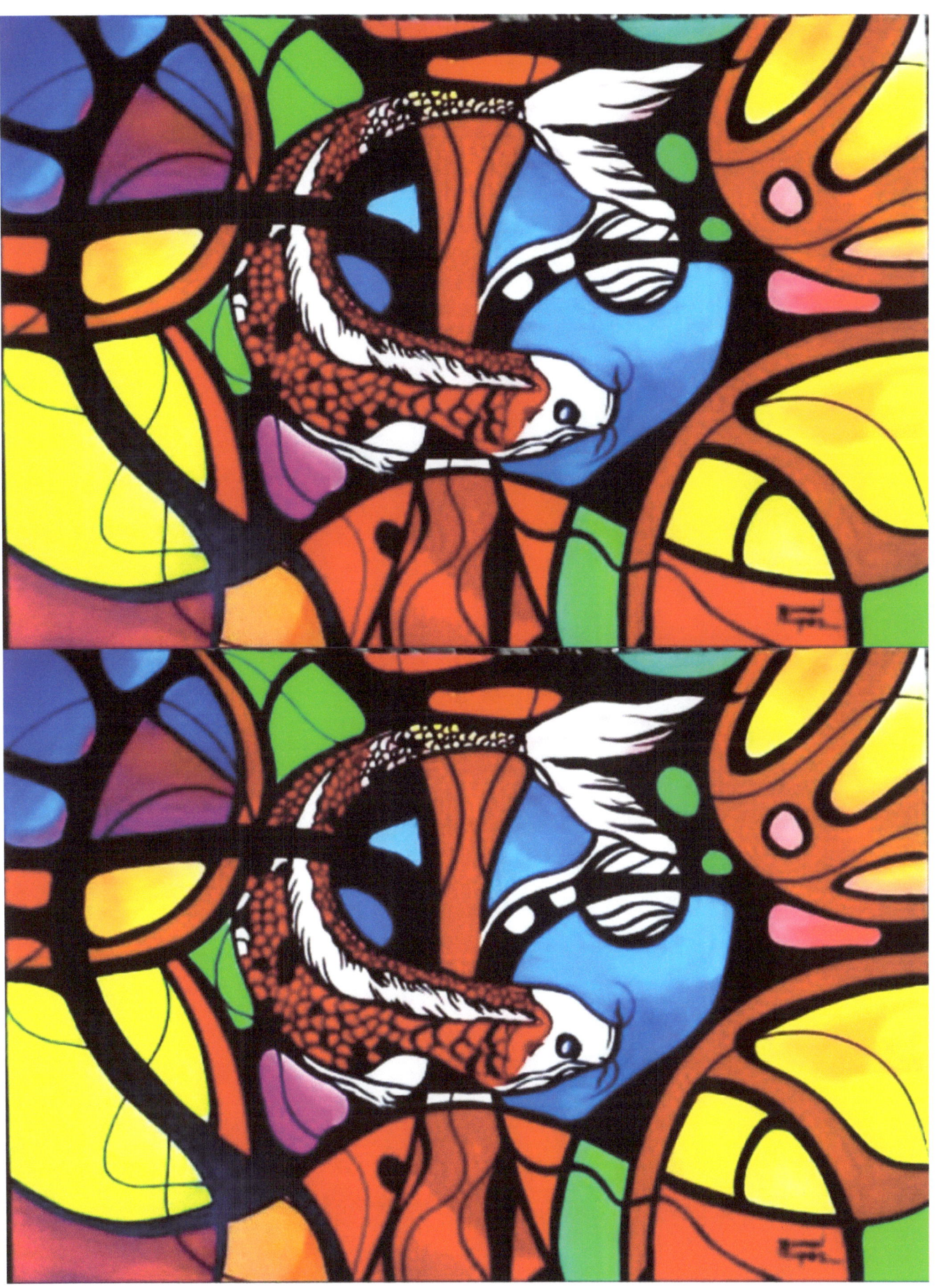

Ramon H. Lopez – The Rustpainter – Second Book Edition

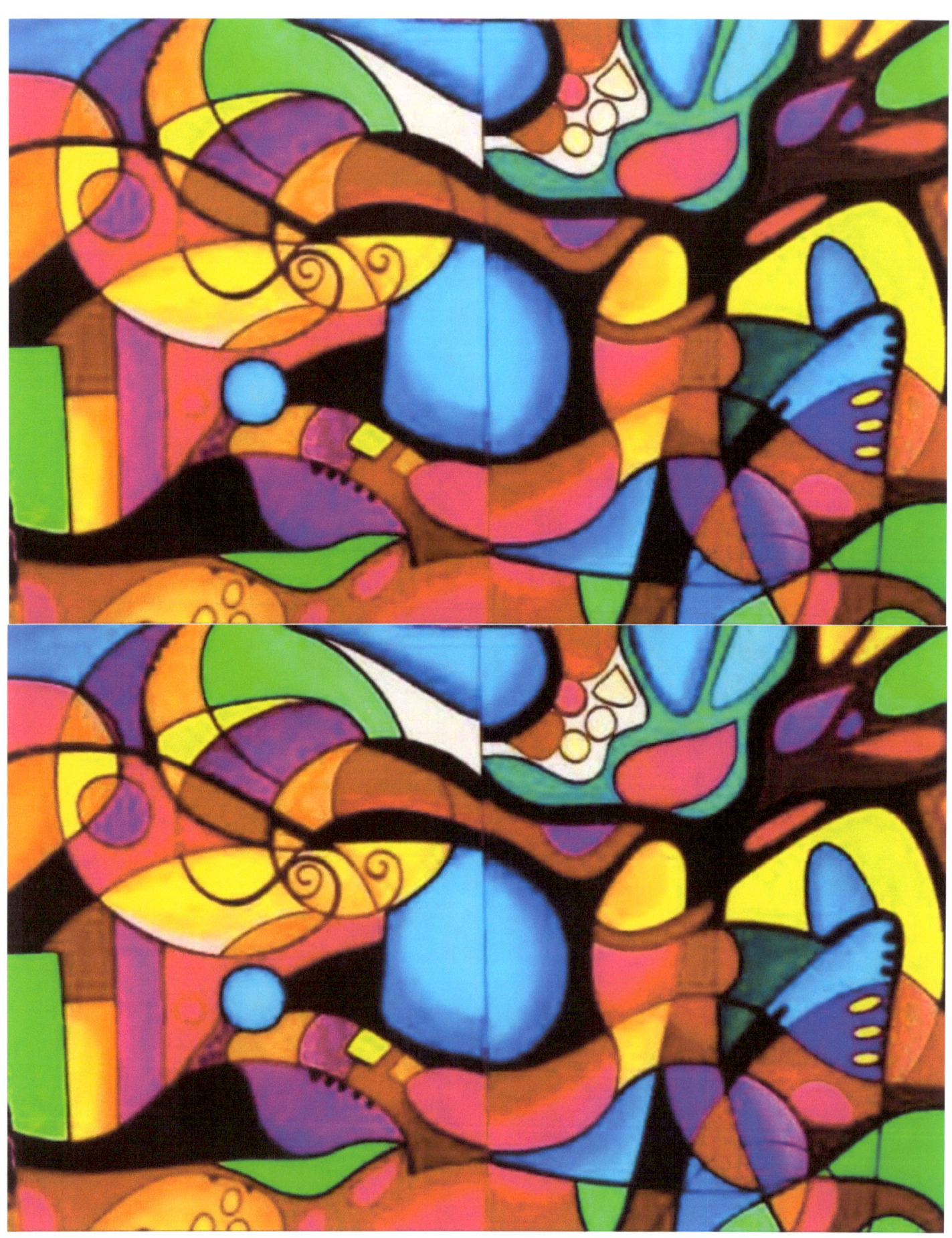

Ramon H. Lopez – The Rustpainter – Second Book Edition

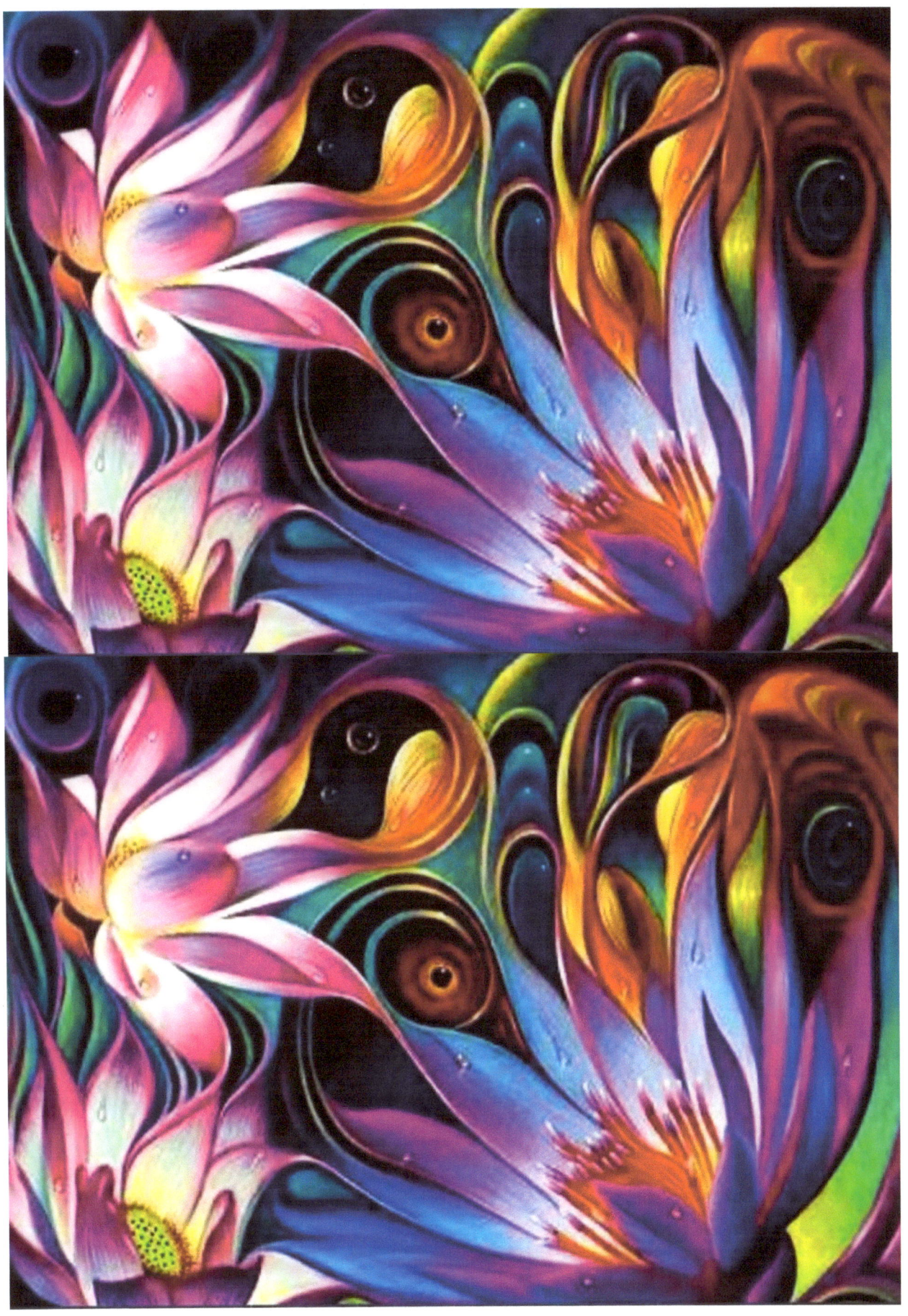

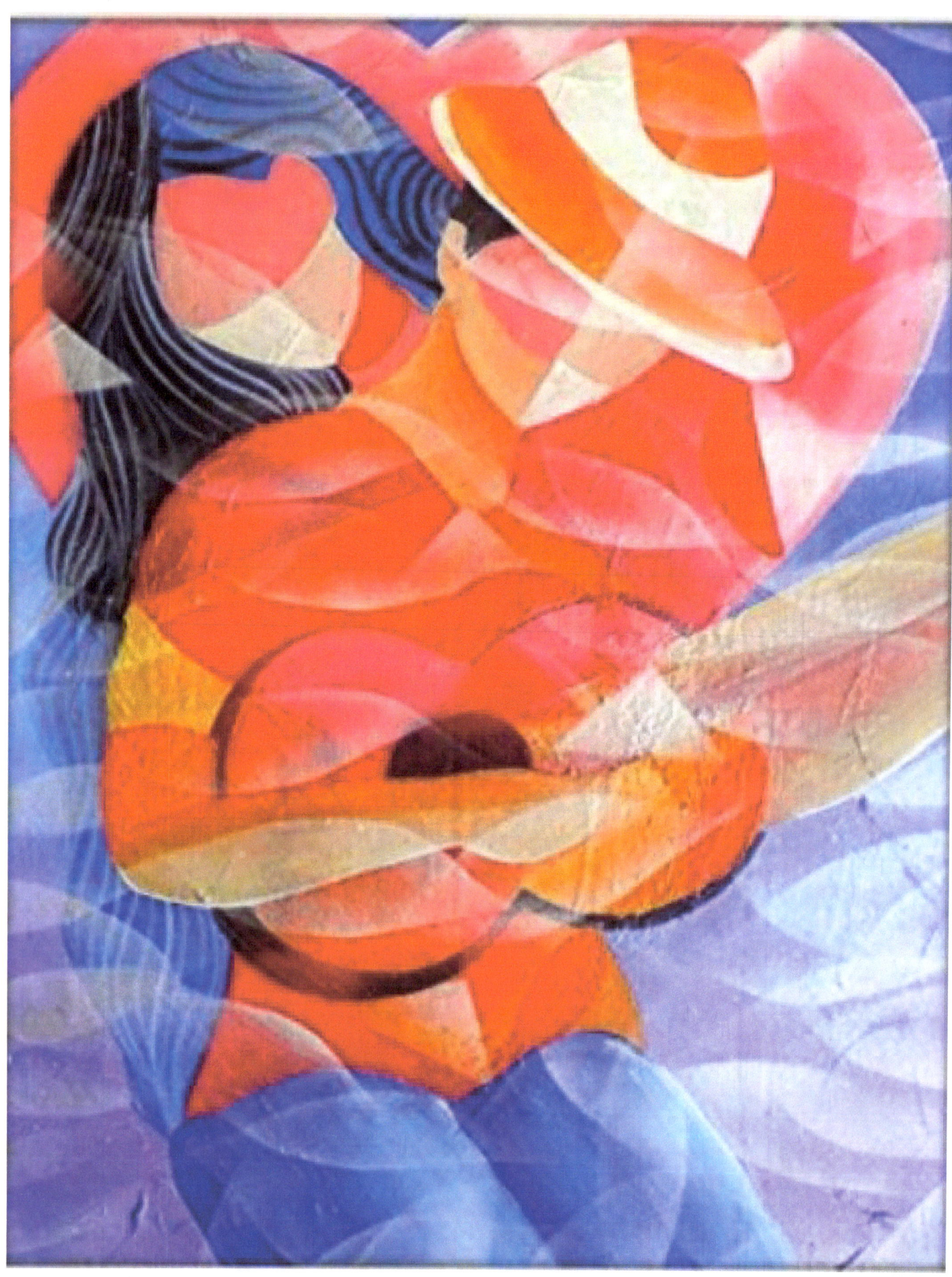

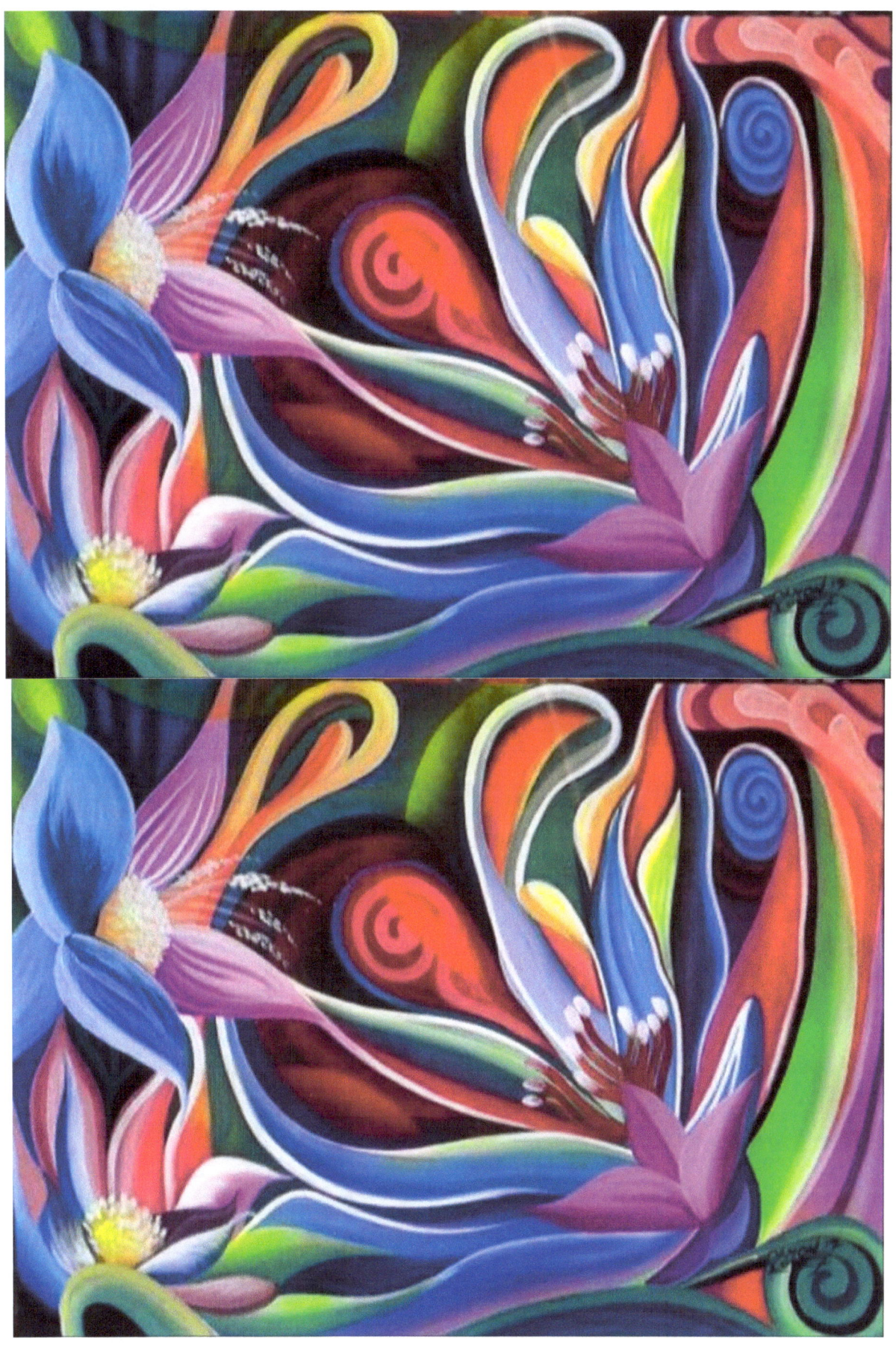

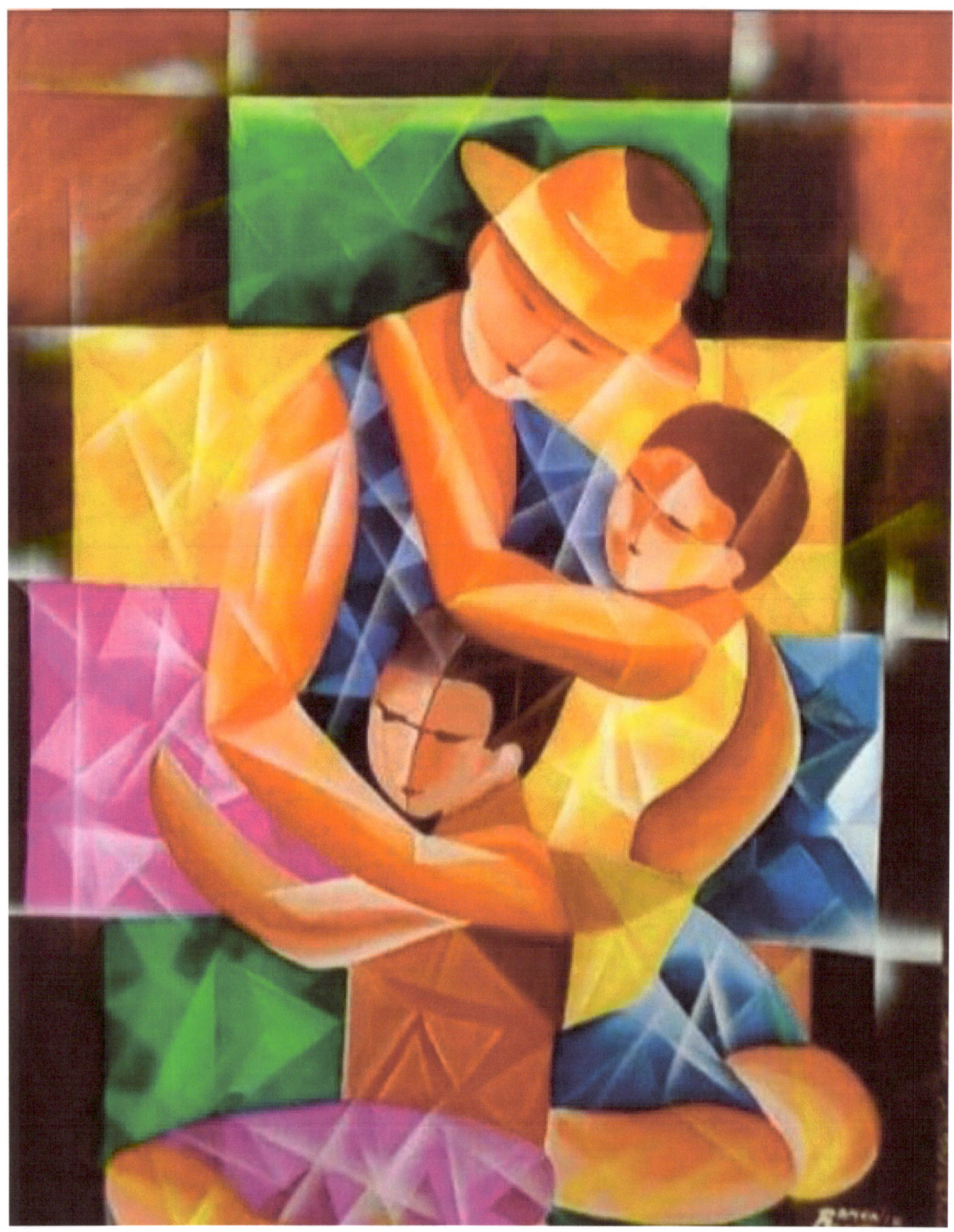

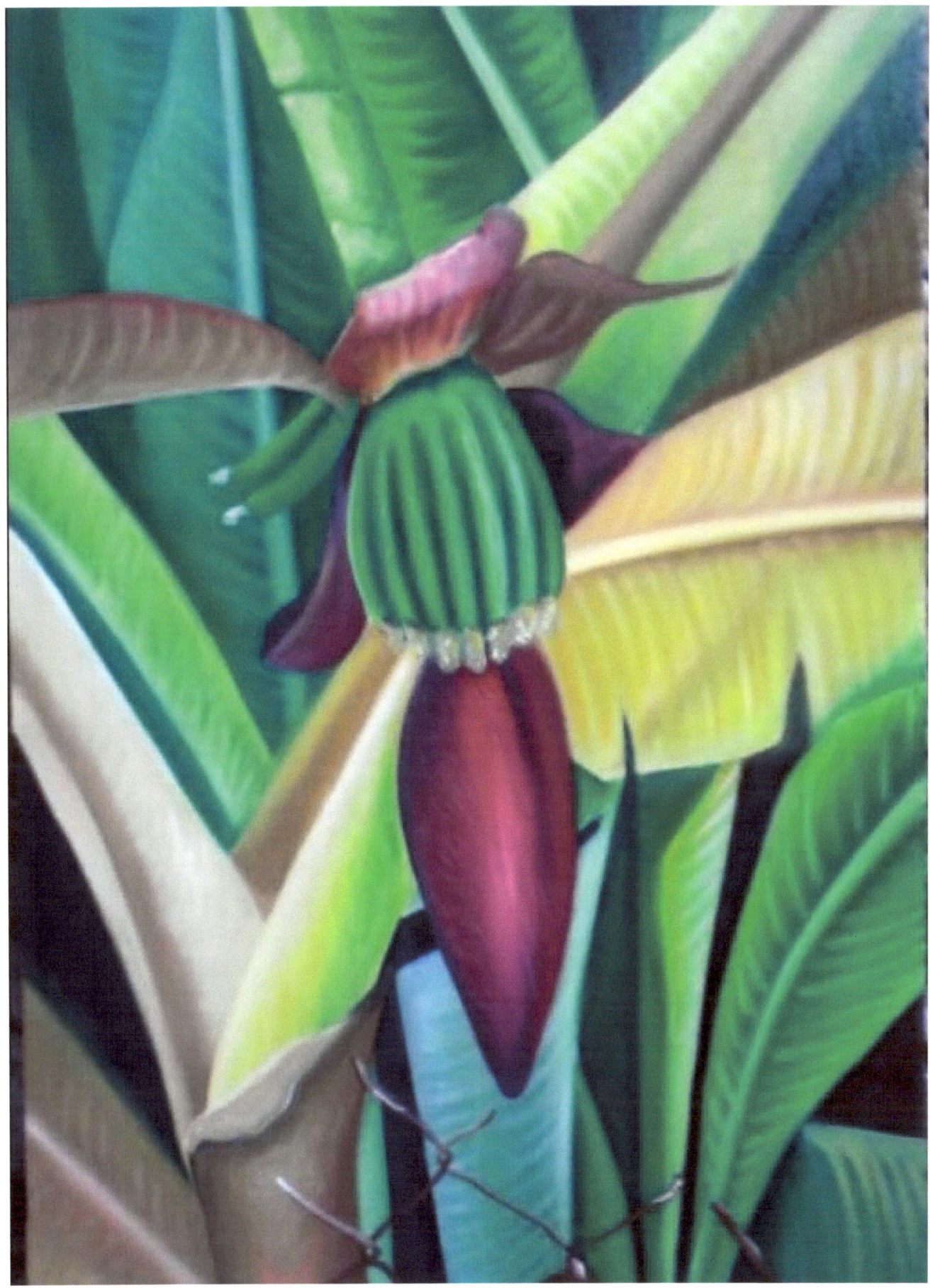

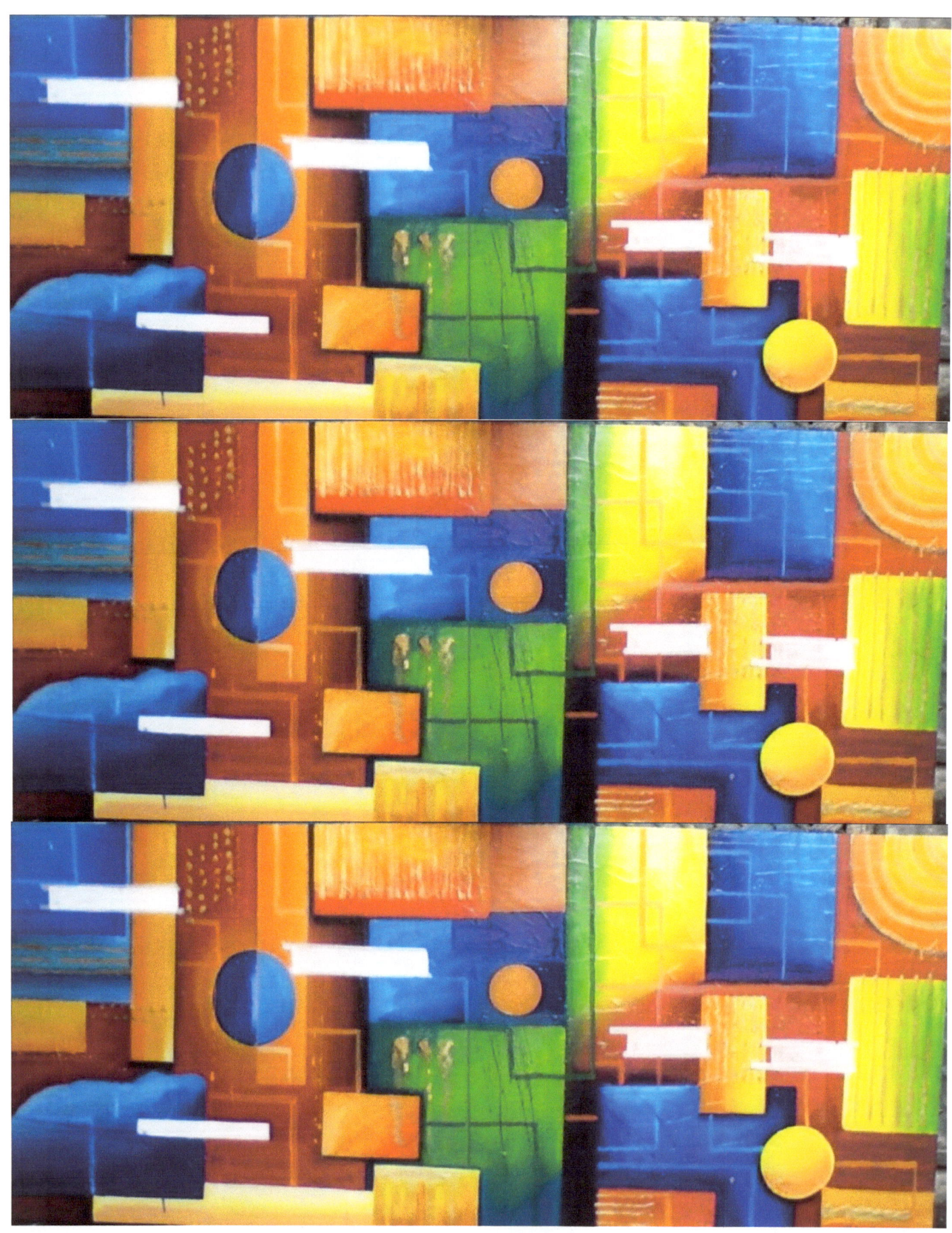

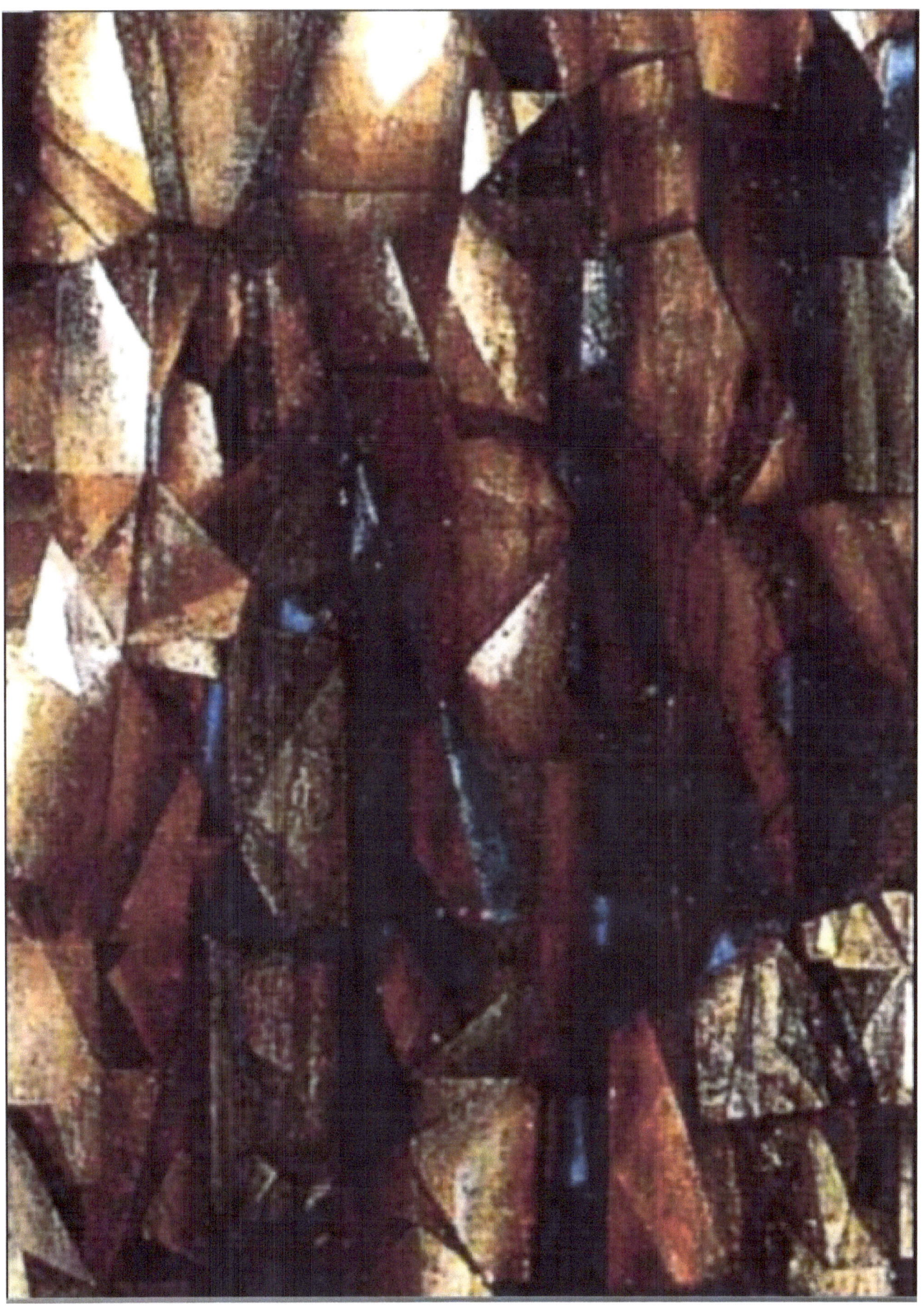

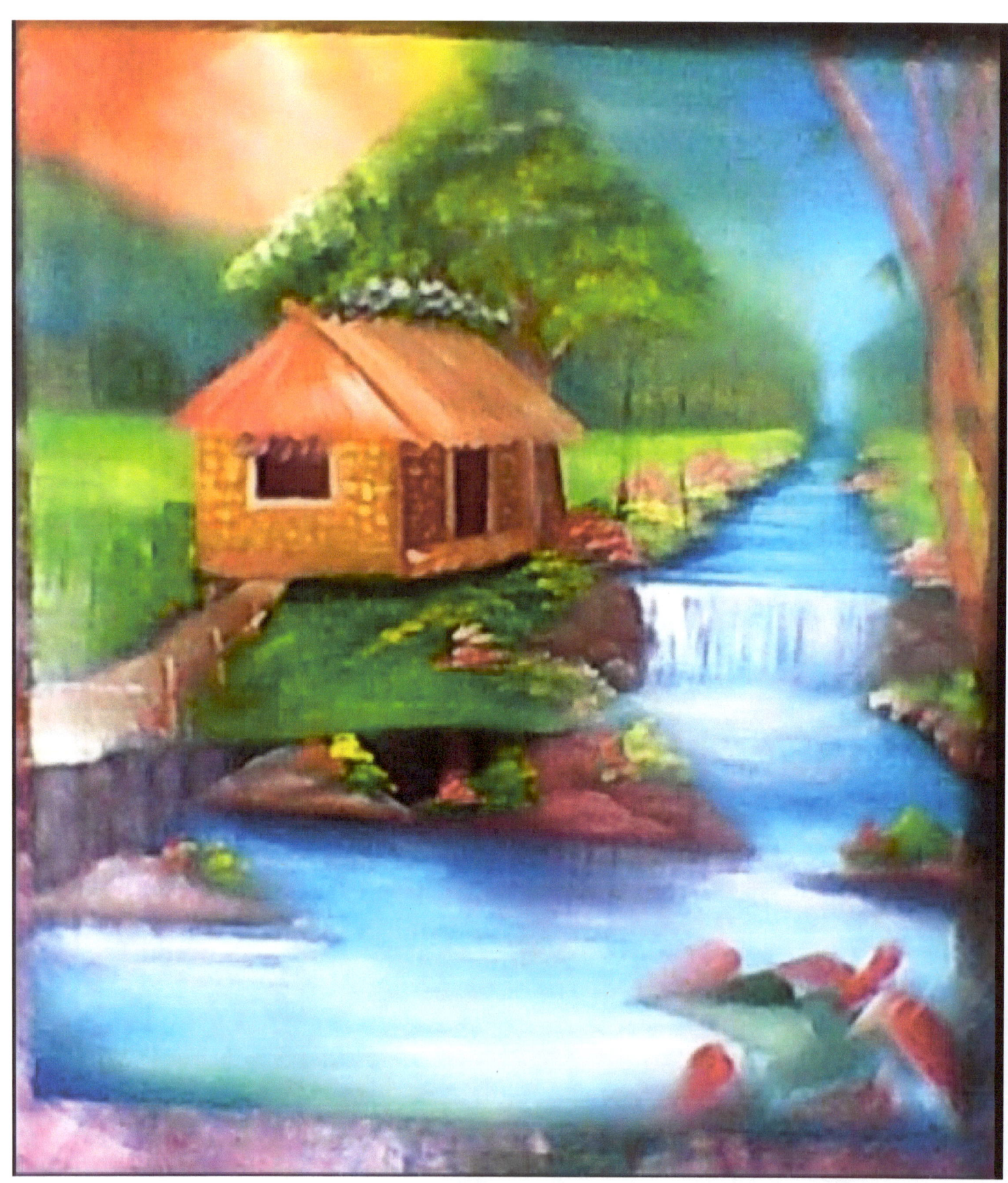

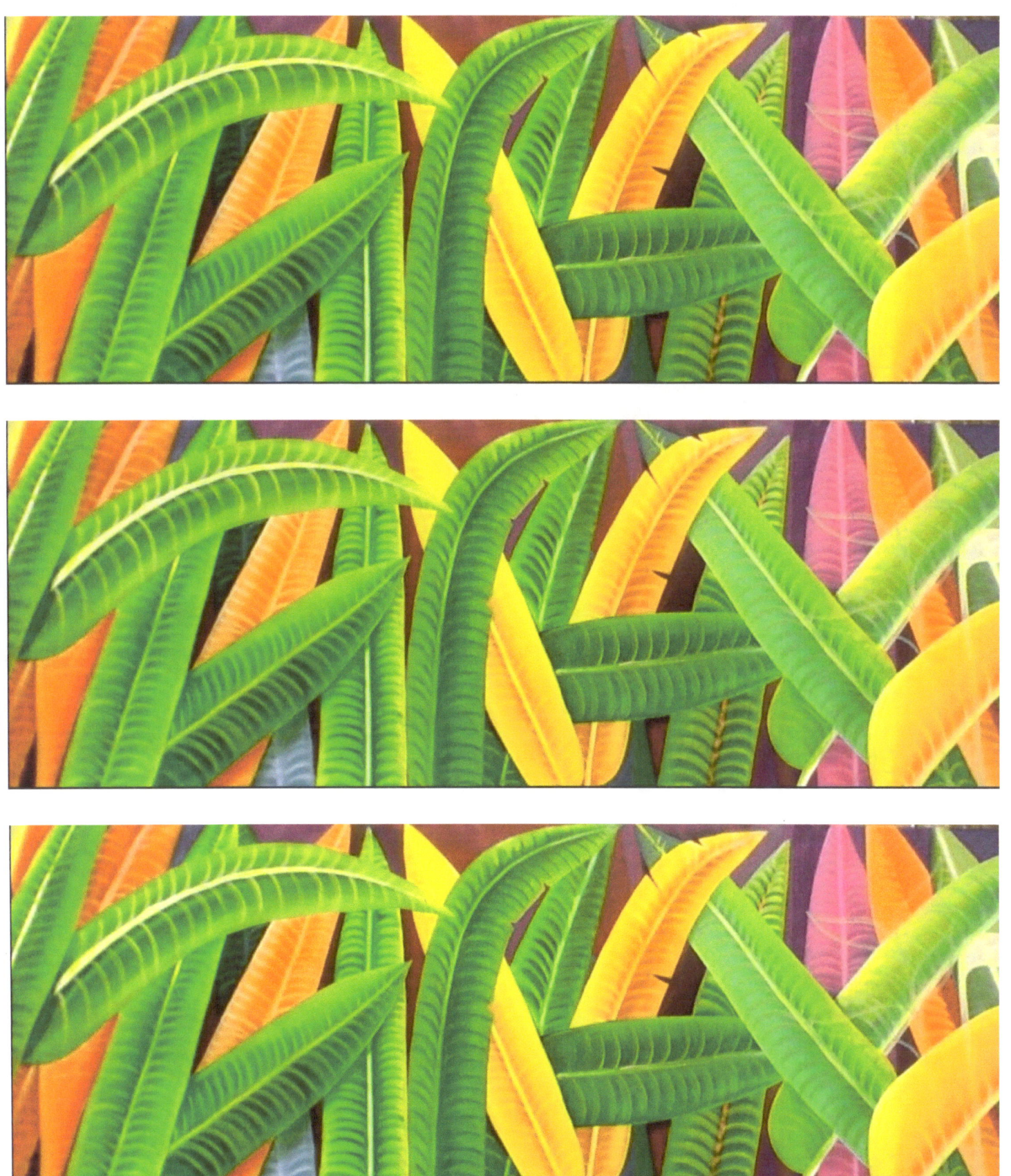

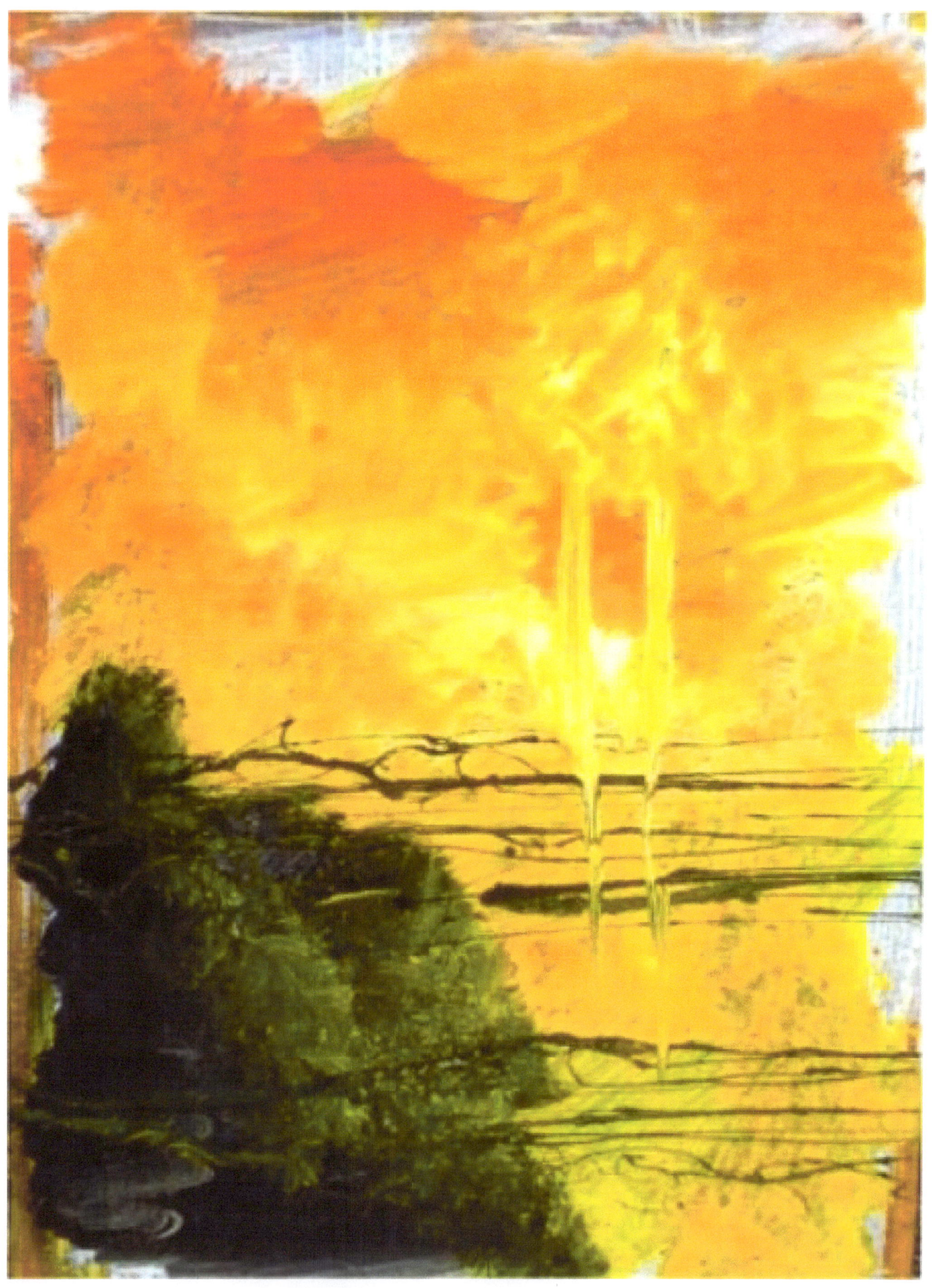

Ramon H. Lopez – The Rustpainter – Second Book Edition

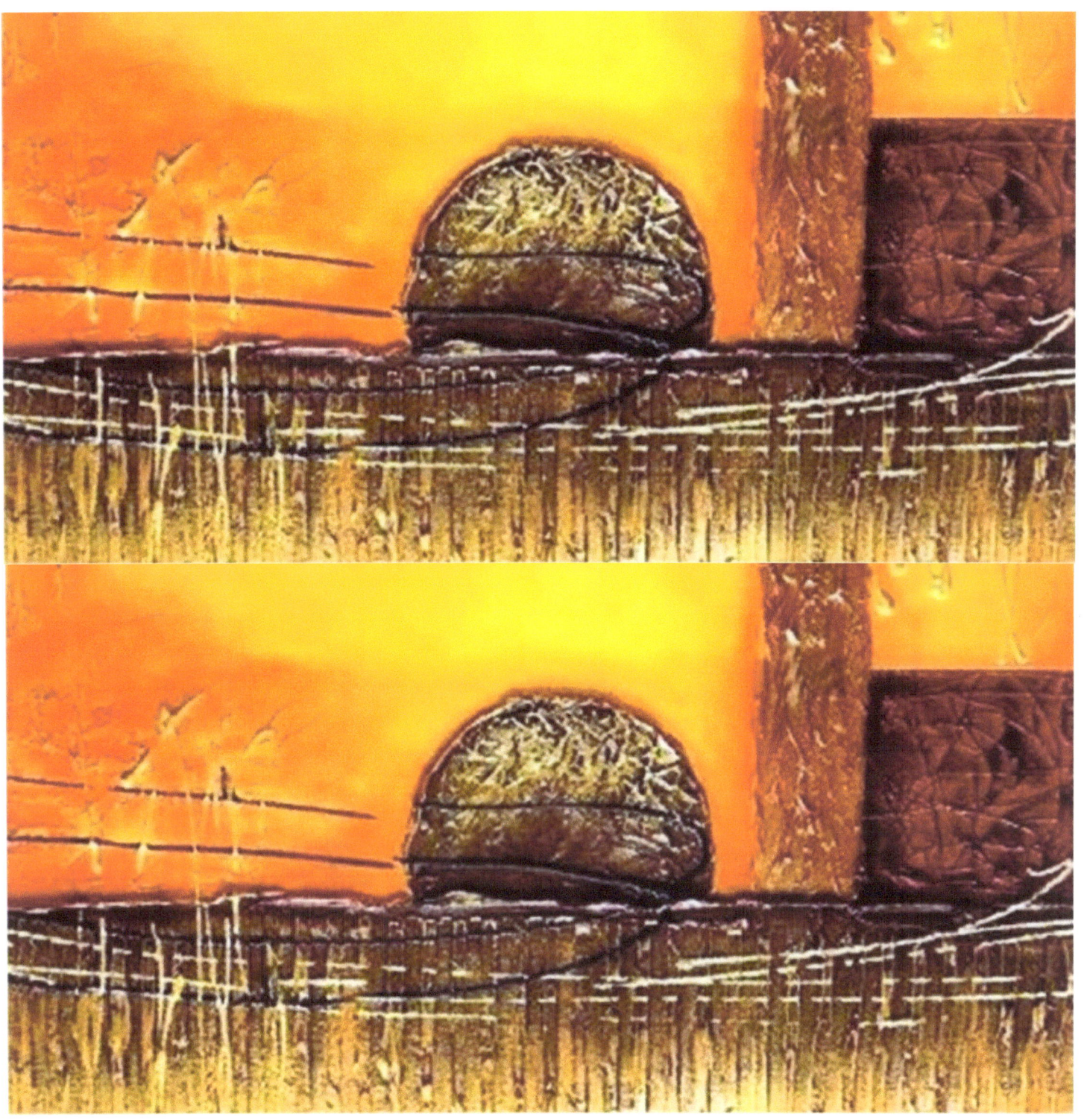

WELCOME! Please enjoy this Ramon H. Lopez Second Art Book Edition with collection of his paintings. You may display this book as coffee table book in your living room, as conversation piece. You may give this as gift. You may cut out and frame each page, sized at 8.5x11 inches and suitable for framing, and for wall decors. Some of his works are for sale. You can also commission him for art jobs. He can be contacted easily at facebook. He lives in San Jose, Nueva Ecija, Philippines.

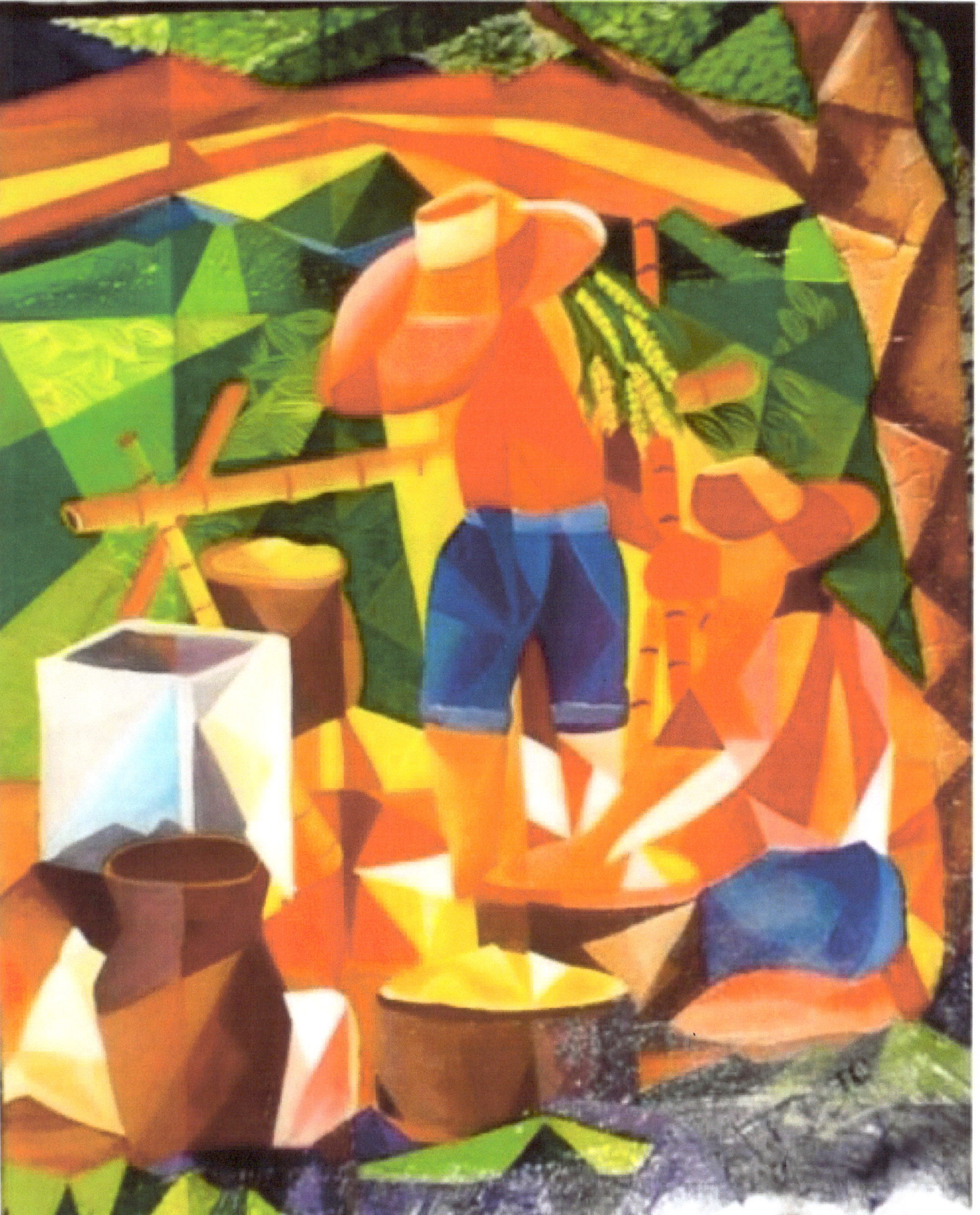

Ramon H. Lopez – The Rustpainter – Second Book Edition

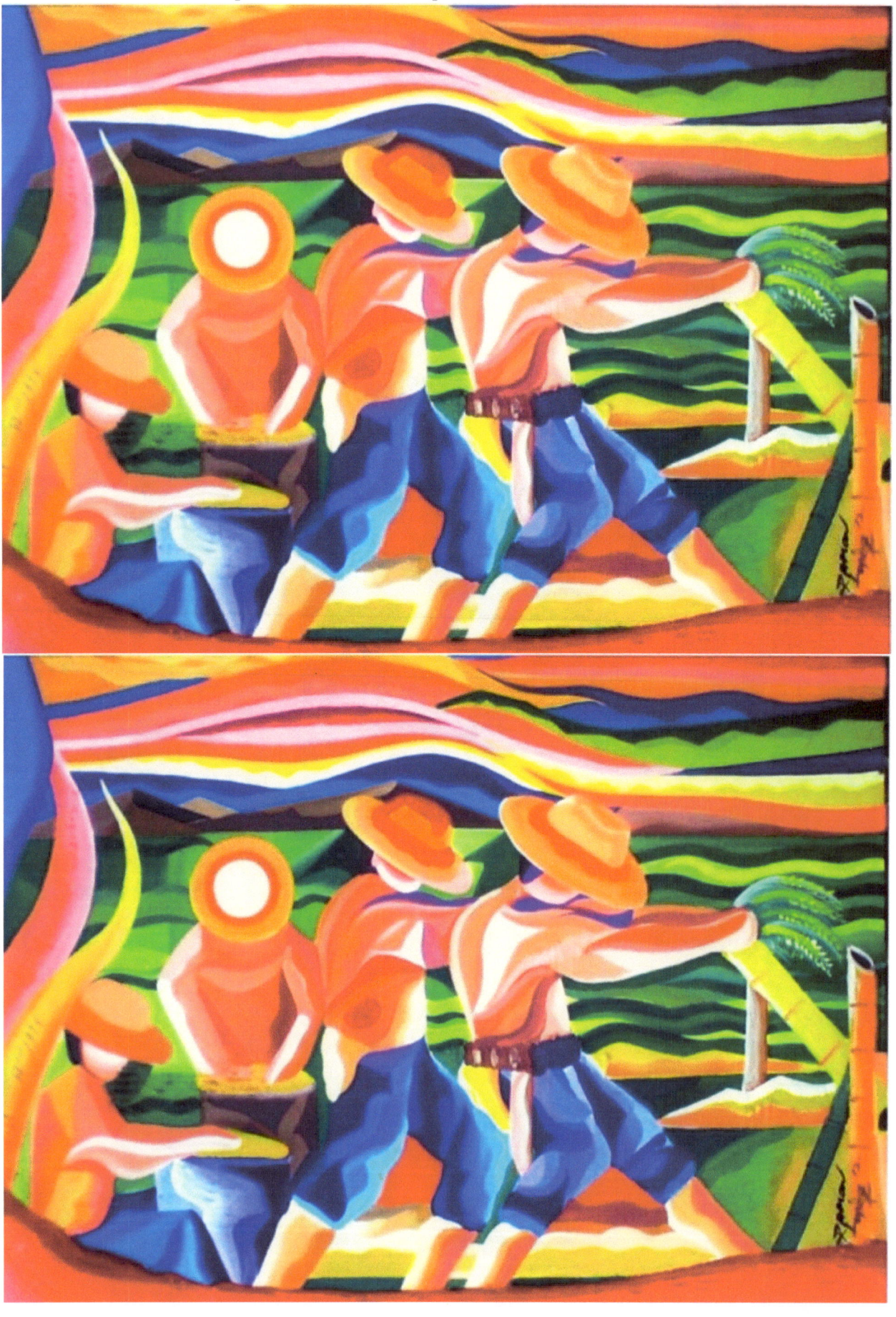

38

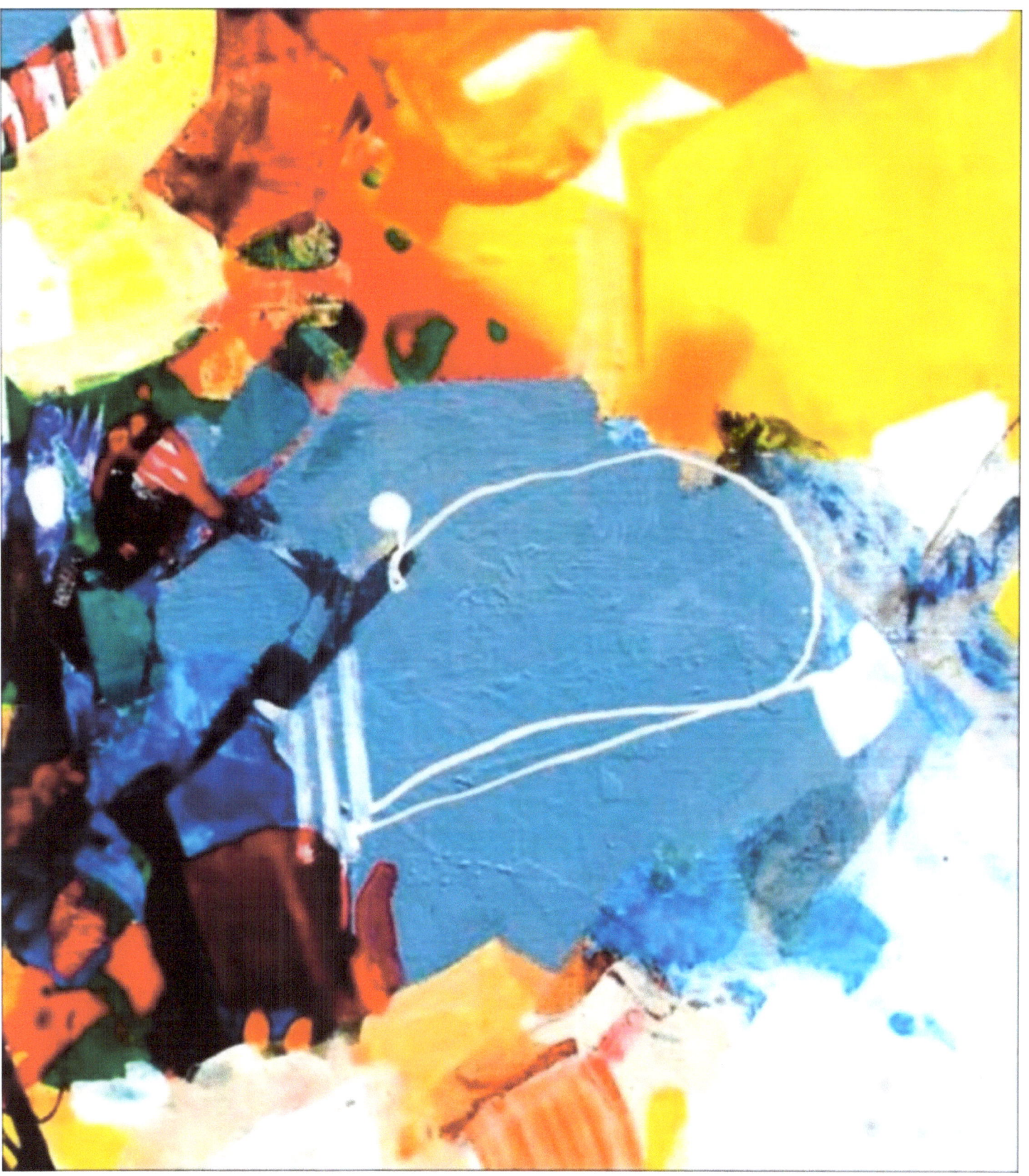

RAMON H. LOPEZ was born in San Jose City, Nueva Ecija on February 1983. In his early years, he grew fond of painting. He wanted to make a name as a painter, not only for himself, but also for the Filipino people. He wanted to make a difference, not confining himself with paint brushes and colors. Lopez still lives in Nueva Ecija. He joined the local art group - Samahang Makasining Phil. Inc. Since he joined the organization, he's craft and discipline have tremendously improved. In 2008, he joined a national painting competition in BPRE. Although he placed 2nd, he's passion for art grew. He wanted to be known for his different style, a style which uses something that we thought is useless. He used RUST as his medium. He started to collect rusting objects from trash, carefully segregating the rust particles which he uses for his art works. He decided to become a rust painter and plans to create more artistic works in the future. He is assured that his works will pass the test of times since he puts top coats in all his works.

www.ingramcontent.com/pod-product-compliance
Lightning Source LLC
Chambersburg PA
CBHW051109180526
45172CB00002B/838